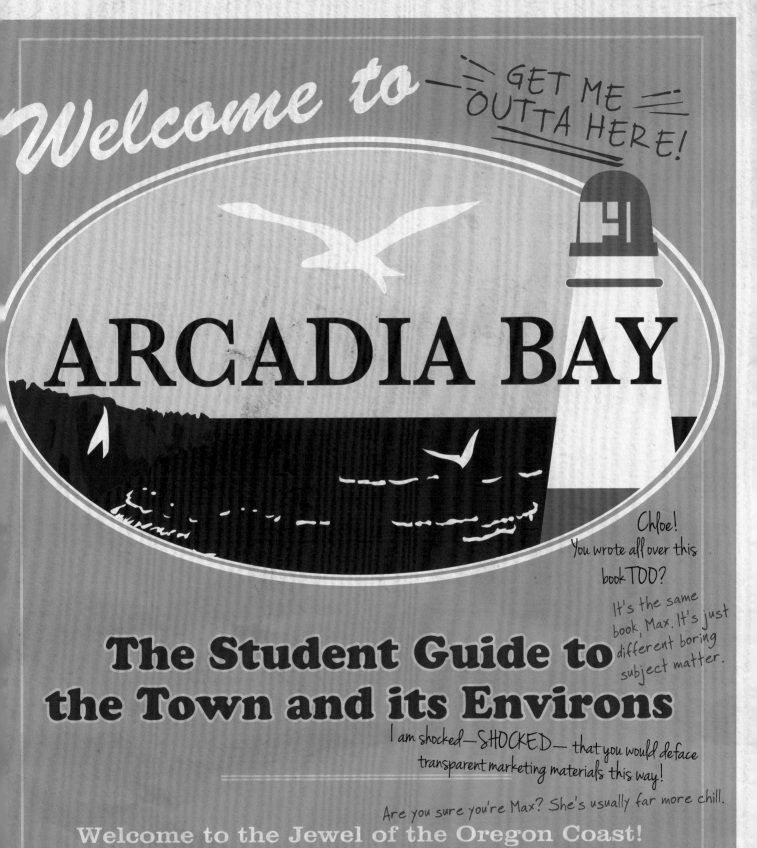

Welcome to

GET ME OUTTA HERE!

ARCADIA BAY

Chloe! You wrote all over this book TOO?

It's the same book, Max. It's just different boring subject matter.

The Student Guide to the Town and its Environs

I am shocked—SHOCKED— that you would deface transparent marketing materials this way!

Are you sure you're Max? She's usually far more chill.

Welcome to the Jewel of the Oregon Coast!

A beautiful, sheltered city on the Pacific Coast, home to Blackwell Academy

HELL

1

A Welcome Message from Pillar of the Community

Explore Oregon **WAKE UP!**

Sean Prescott

Despite all efforts to remove them. Seriously? How are these assholes still here?

Money? Lots and lots of money...

Welcome, one and all, to Arcadia Bay, the jewel of the Oregon Coast. My family may have been here since the town's founding, but one trait that every resident of this wonderful locale has always shared is their willingness to welcome new faces into the fold. From the Native Americans that originally called our sheltered little bay home, to the town's proud residents today, we're always happy to see new people and invite them to enjoy our community.

Notice we don't see too many of them around here these days.

That's damn sad...

At least they don't have to live here anymore!

Students are always especially welcome in Arcadia Bay—and not just because they bring outside money into town! They also bring their curiosity, their passion, and their desire to make the world a better place. That's something the people of Arcadia Bay appreciate more than anything. In fact, that's exactly why Jeremiah Blackwell founded the school that bears his name one hundred years ago.

While Blackwell Academy may be the biggest draw for students admitted to that most prestigious school, Arcadia Bay itself has plenty of charms to enjoy, both for students and their visiting families. We have beaches on one side of us and mountains on the other, with miles of parkland all around. We have a charming main drag downtown, at which you can find everything from quaint shops and restaurants to upscale dining options too.

Translated: RUN DOWN

Translated: TOO RICEY FOR YOU PEASANTS!

Translated: FUGLY

This is a wonderful place not just to go to school, but to vacation in as well. And most of all, it's a fantastic place to live. Peaceful, gorgeous, and full of kind people with ambitions beyond the borders of their homes. Join us here for a while and see if you don't agree.

Who in their right mind would ever live here by choice?

Hey, I came back here voluntarily.

Only proving my point. ☺

Sean Prescott

Didn't he write an essay on the other side of this book?

Well, when you're paying for just about everything in town, they let you write whatever self-important shit you want. Or so I hear.

Map of Arcadia Bay

Max and Chloe's OFFICIAL
Map of Arcadia Bay!!!

1. Oh, I'm a big building, and I'm SO important
2. Last House on the Left
3. Giant Horizontal Ladder to Nowhere
4. BlackHELL!!!
5. The Beach... bitch!

6. B-movie Rocket /Home base of Animaniacs
7. Local Serial Killa
8. Shootin' Range
9. More Beach... BEEEATCH!
10. I'm feeling tense

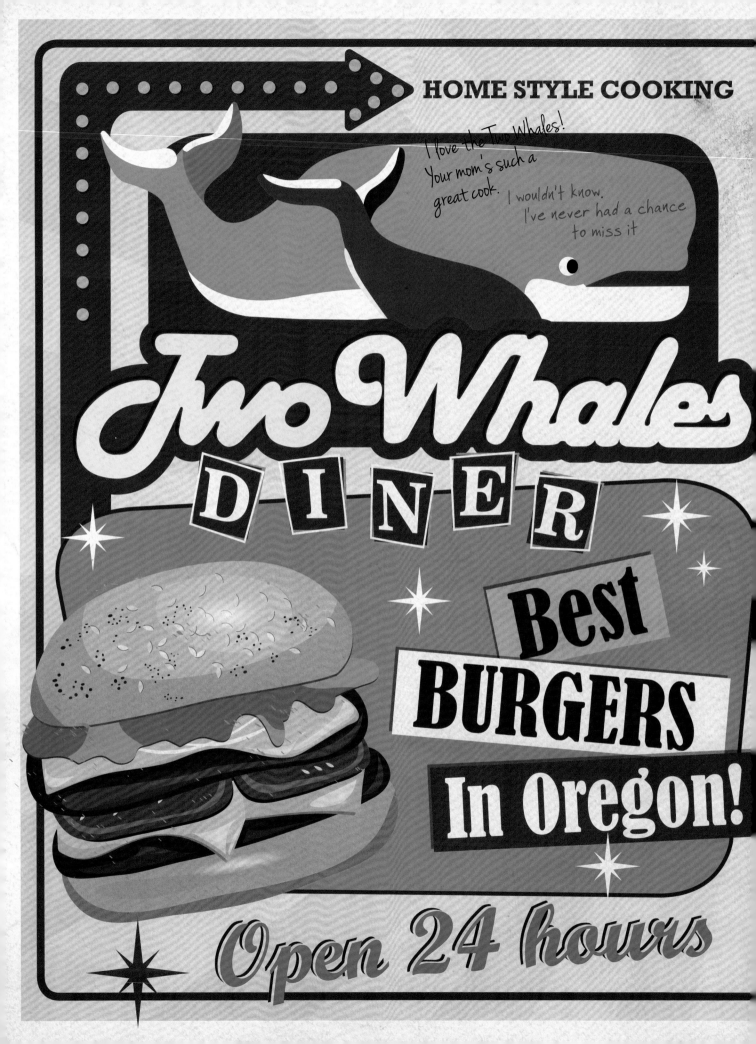

Come on down to the most popular restaurant in all of Arcadia Bay: the Two Whales Diner! We feature homestyle cooking guaranteed to help drive those homesick blues away.

Be sure to ask for our:

LEGENDARY CRAB CAKES

or

STARFISH PANCAKES

and don't forget to add a side of our

BIGFOOT BACON!

GO, BIGFOOTS!

They're called that not for their shape but by how rotten they taste, right? Fuck you, Victoria!

HOW MANY BIGFOOTS HAD TO DIE FOR THIS BACON?

I assume you're talking about the creatures in the woods and not members of Blackwell's sports teams. EITHER WAY. I NEED TO KNOW!

We have student specials
from 6–10 AM daily!

They're serving students? ON PLATES?

How are they prepared?

Just remember, bad students are never prepared!

Life in Arcadia Bay

Life in Arcadia Bay runs at a different pace than you might be used to. We have our own kinds of delights to discover around every corner you turn. Here are a few details you should be sure to look out for.

Our farmers' markets feature fresh dairy, meats, and produce—and you can find many of those elements on the tables of our best restaurants, which pride themselves on their farm-to-table offerings.

The winter is crab season! Be sure to grab some for your holiday feasts or enjoy crab cakes while they're in season.

I suppose that beats chlamydia season... *Grooooooss!*

Oregon has 363 miles of Pacific Ocean coastline, and you can see the whole thing by driving down Highway 101—which runs straight ~~through~~ Arcadia Bay!

AWAY FROM

Be sure to check out our amazing state forests nearby— and the national forests throughout the state.

And watch them burn like matches... *I'm sure that was an accident. Riiiight?*

Enjoy our favorite pastry: elephant ears! These are big flats of fried bread coated with delicious sugar, sure to delight your taste buds. *And then make your head explode from the sugar rush!*

That's really what got me hooked on altered states...

Here in Arcadia Bay, it's almost always too warm to snow!

Considering how hellish this place is, you'd think it would be warmer...

We live in an extremely temperate climate. Even in the dead of summer, our average high temperatures are less than 70° F.

Bring an umbrella! We have many rainy days over the course of an average year, although it's not nearly as bad as most people fear. The showers are generally short and gentle and end fast.

Just like Kate Walsh...

You're such a bitch!

We have a strong history of dairy farms in the area that produce world-renowned cheeses.

And an epic amount of cow manure. *Say, "shit," Max. You're among friends.* *Shit, you're right.*

The original residents of Arcadia Bay spoke a dialect of Salishan a language used throughout the Pacific Northwest.

The Native Americans who lived here were renowned for their basket-weaving skills, and versions of their baskets are sold in stores throughout the area.

Blackwell Academy is known throughout the state and the nation, bringing in students from all around the country.

The Arcadia Bay Lighthouse that looks down over the city has been in continuous operation for over one hundred years. It's become a well-known national historic landmark.

The streets of Arcadia Bay are extremely safe. Our crime rate is wonderfully low!

I don't know which streets they've been walking down...

Maybe those streets are so rotten because you're on them?

I live on the corner of Fun and

FUCK YOU, VICTORIA!

Our population is growing steadily, but we still number less than 5,000 people. We like to say we're a small city with big-city ~~amenities!~~

ENEMIES *AMMONITES* *MAMMARIES* *OVARIES* *WHY ARE WE YELLING?*

Read All About It!

The tradition of the free press is alive and well in Arcadia Bay! No matter who you are, or what your interests, you have plenty of options for learning more about your community and what's happening in it.

How are all these rags still in business? We can't possibly need five different angles on Arcadia Bay's excuses for news.

It's a fishing town. We wrap a lot of fish.

This weekend-only newspaper covers events in our entire county, concentrating, of course, on Arcadia Bay.

This monthly newszine helps you plan your weekends by highlighting fun and interesting things to do throughout the entire region.

Amazingly, it's filled with blank pages every mont

All the better for drawing in..

This twice-weekly newspaper covers local events and is a bonanza for shoppers looking for deals.

This weekly newspaper concentrates on offering locals an alternative view on the news, along with a deeper dive into ecologically conscious activism.

The only stoner source of news in town!

Other than you, you mean?

This daily newspaper covers all events in Arcadia Bay and beyond. It features the most comprehensive coverage of all our many papers.

The History of Arcadia Bay

Arcadia Bay was originally settled by Native American tribes, who lived here in harmony with the wilderness, living off the largesse of the land and especially the bounty of the sea. Captain William King, a Scottish explorer looking for signs of the Northwest Passage, landed here in 1792, and the local residents welcomed him and his crew with open arms. King and the others of the *Arcadia*—the sloop on which they sailed— were so taken with the hospitality of the natives and the beauty of the land that they decided to drop anchor here for several years.

How appropriate. Our town was named after someone who was totally fucking lost. And then they left! My heroes!

It wasn't until March 14th, 1838, that Ezekiel Blackwell set out with a group of Pentecostal settlers on an expedition from Independence, Missouri, for Oregon. They arrived nearly a year later, on March 3rd, 1839, and set up camp in what is now known as Overlook Park, inside of Culmination State Park. From that spot on the slopes of Culmination

"Overlook"?
"Culmination"?

The Blackwells
were NOT poets.

Poetry's
overrated.
JUST GIVE ME
RHYMES!

In better TIMES.

I need more, um,
LIMES? MIMES?
(Shit...)

That was SUBLIME.

Peak, they could see the Pacific Ocean, and they knew that they had finally reached their goal.

They founded a town called Culmination on that spot, as it represented the culmination of all their dreams. They later ventured toward the coast, where they discovered Native Americans who, to their surprise, spoke some English. They informed Ezekiel that the area was named Arcadia, and Blackwell and his people adopted the name for Arcadia Bay.

Over the course of the centuries, the quiet settlement of Arcadia Bay, named after the ship that brought King and his people to our land, became a bustling town. Back then, the economy was based on ~~logging and fishing~~, *SCHOOLS* much as it is to this day. When the railroad finally *and DRUGS* reached the town in 1892—a hundred years after

King's ship—Arcadia Bay also became a vacation destination, renowned for its temperate weather and awe-inspiring vistas.

By that time, Jeremiah Blackwell was already setting his plans for Blackwell Academy into motion. They finally came to fruition in 1910 when the doors to the school opened to admit its first classes.

Blackwell Academy brought many benefits to our city, beyond just an excellent educational option for our students, outside of our public school system. It also brought many people who fell in love with Arcadia Bay during their time here and decided to stay. This includes the well-known and much respected Prescott family, which has sent several generations to Blackwell over the past century.

So, it's Blackwell's fault we can't get rid of the Prescotts? BASTARDS!
You left this open to this page on my chair?
What the fuck is wrong with you?

Nothing that a lot less Prescott in my life wouldn't fix.

Arcadia Bay managed to weather many troubling times through the course of the 20th century. During World War II, for instance, the city was nearly abandoned as every able-bodied man went to serve in the armed forces, while most of the rest of the population moved to Portland or Seattle to help with the war effort. After the war, though, most people returned to a grateful Arcadia Bay, and the town thrived once more.

Today, Arcadia Bay is a bustling gem on the Oregon coast. People travel here from around the country, looking for a peaceful place that can provide them with the natural beauty and pace of life that no metropolis could ever manage. They soon learn what our long-time residents already know: there's no better place on Earth.

Nice how they totally ignore how the Great Recession has hollowed out the town. The only people doing well around here these days are the Prescotts!

We got ours! Fuck you!

You're the poster boy for the Blackwell Young Republicans, aren't you?

OREGON

Life in Oregon ~~SUCKS~~

There are a few things we do differently in Oregon. If you're from out of state, be sure to pay attention. Here are a few of the details you should look out for:

We have no state sales tax, which means no surprises at the cash register. What you see on the price tag is what you pay!

Apparently only experts can manage such amazing feats without bursting into flames!

By law, you cannot pump your own gas. When you pull into a service station, someone will come out and take care of that for you!

You'd like to see that, wouldn't you? Hey, I'm not the firebug here...

Oregon is consistently ranked among the best states for business.

Chloe! We HAVE TO DO THIS!

Visit Crater Lake, Oregon's only national park, and check out the rock formation known as the Phantom Ship for how it resembles a pirate ship!

Captain Chloe and First Mate Max sail again!

What about those of us BORN here, huh? CANNOT WAIT

WARNING: Most people who move here never want to leave!

If you're in Oregon in the summer, be sure to check out the Oregon Country Fair, a three-day festival held outside Veneta, Oregon, less than three hours away by car.

Wonder if they need anyone for a production of The Tempest...

If you like our theatre productions, join us for the Oregon Shakespeare Festival in Ashland too. Some Blackwell Academy students have tripped its limelights!

You are NEVER getting me to do that again. Don't dare me!

Residents of Renown

Arcadia Bay's biggest strength isn't its land or its coast—but its people. We're blessed to have so many strong leaders in our little community, and we'd like to highlight a few of the most notable ones here.

THE'RE WATCHING

Mayor Libby Cochran

Mayor Cochran grew up here in Arcadia Bay and attended Blackwell Academy. After attending the University of Oregon, she worked in the state legislature in Salem as a political staffer for several years before returning home after the death of her father, who himself served as our mayor for three decades. The following spring, Libby was elected to replace her father, and she's been faithfully serving the city ever since.

Sheriff Ronan Newell

Sheriff Newell was an FBI agent when he first came to Arcadia Bay to investigate a rumor that infamous skyjacker D. B. Cooper was hiding here. While that proved not to be true, Newell fell in love with the town. When an opening for deputy sheriff opened up, he applied for it straight away, and a decade ago he took over as our sheriff.

Why did you put the sheriff's number on your posters looking for Rachel Amber and not the police?

Have you MET our police officers?

Chief Mitchel Camber

Chief Camber came to Arcadia Bay from North Bend, Washington, where he'd served as the deputy chief for a decade. He brings the same kind of small-town police mentality to the head job here in Arcadia Bay. While our police force may be small, Camber's officers work hand-in-hand with the sheriff's department to keep our streets safe.

Translated: Don't trust these tiny-brained fuckers. The Prescotts have them stuffed in their pockets.

District Attorney James Amber

James Amber grew up in southern California and attended UCLA for both undergraduate and law school. After his daughter Rachel was born, James and his wife Rose decided to look for someplace quieter to raise their little girl. They soon settled upon Arcadia Bay, where James took a job as a prosecutor. He ran for district attorney in 2006 and won handily.

Daddy!

I think you mean, "That rancid, lying fuck."

ONE AND THE SAME!

Principal Raymond Wells

Raymond Wells first came to Arcadia Bay to study at Blackwell Academy. He returned many years later to take over as its latest principal. He's become a treasured administrator there and a well-known man about town. On weekends, you can find him at his wife Georgia's stand in our farmers' market, helping her sell her delightful scented candles.

I-I don't think I could come up with a worse fate for the man if I tried.

Superintendent George Wolchezk

George Wolchezk grew up in Seattle, but he went to school at Oregon State, where he received his doctorate in education. He spent several years as the principal of Neah-Kah-Nie High School in Rockaway Beach, Oregon, and when the Arcadia Bay school board was hunting for a new superintendent, his name was at the top of the list.

Fate takes care of itself once again...

Kathy Coulson

The Coulsons have owned a number of newspapers in Arcadia Bay over the years. Kathy married into the family after meeting her husband Keith at the University of Washington. Upon his passing in 2002, Kathy took over the operation of their papers, including *The Great Northwest*, *The Arcadia Bay Beacon*, and *The Arcadia Bay Gazette*.

Hard as it might be to believe, this asshole actually makes me feel a little sorry for Nathan.

Sean Prescott

The current patriarch of the legendary Prescott family, Sean is the CEO of Prescott Industries, the largest employer in town with the deepest pockets. Over the decades, the Prescotts have done tremendous good for our society, sponsoring all sorts of cultural events and supporting Blackwell Academy in a deep and abiding way.

Fuck off, you half-orphaned, druggie whore.

See, and now that's passed.

Amenities, Services, Shopping and Restaurant Guide

GHERKIN!

Unlike the homogenized, franchised strip malls you find in larger cities, the business district of Arcadia Bay has a unique flavor all its own. Here are some of the brightest stars you can find in our town's constellation.

Arcadia Bay Drive-In
It's true! Arcadia Bay still has a drive-in movie theater outside of town. As a tribute to our temperate year-round climate, it's open in all seasons. Shows start after dusk, and they often show a double feature. Sometimes they even triple it up for the long winter nights!

Arcadia Bay Sheriff's Department
The Arcadia Bay sheriff and deputies do more than just enforce our laws. They also help patrol our parks and shores, keeping the region safe for everyone. Their friendly faces always greet you with a smile!
You can reach the sheriff's department at 555-388-6020.

Oh, yeah?
WHERE THE FUCK IS RACHEL AMBER?

Arcadia Bay Hospital
Although we hope you'll never need it, the Arcadia Bay Hospital has recently refurbished its emergency room. The hospital also offers clinical services, and it has an excellent relationship with Portland State University, to which it refers patients who need additional help.

And don't worry! Because of our nation's insane healthcare laws you'll only be rendered destitute by the slightest of ailment

Remember kids, ILLNESS IS YOUR MORAL FAILURE.

ACFC Drive-Thru
If you're looking for fried chicken, clams, and crabs with a Northwest kick, you can't do better than Arcadia's Crazy Fast Chow, better known as ACFC! Order and pick up your food through their drive-thru, or sit down and relax in their spacious dining room at any of their three locations. It's delicious either way!

This is the grossest shit around. Also the best cure for the munchies EVER!

ellow
WORLD

Mark Jefferson had a display there once.

Oh! I wish I could have seen that!

Arcadia Gas

If you need to fuel up while you're in town, there's no better place than Arcadia Gas. Their three locations feature the excellent full-service pumps you expect in Oregon, and they'll get you gassed up and on your way in no time at all.

Arcadia Pawn

Shoppers looking for a good deal have no further to hunt than the shelves of Arcadia Pawn. The place features all sorts of goods for sale, including some real antiques!

Stay classy, Arcadia Bay!

Bean Hip Café

Oregonians love their coffee, and there's no better place to find it than at the Bean Hip Café, where expert baristas will conjure up a delightful cup of your favorite blend of brew. While you're there, be sure to check out the walls, which often feature exhibitions by local and even nationally known artists.

For when you absolutely have to get your barely legal buzz on...

Harbor Inn

While we have a number of hotels in the area, none of them are closer to the shore than Harbor Inn, which has spectacular views of the entire bay. They also offer some of the freshest seafood in town, taken straight off the dock!

...and then hopefully CLEANED Like, scrubbed until the herpes comes off CLEANED BLORK

Pacific Steve's Famous Crab

During crab season, there's no better place to eat in town than at Pacific Steve's Famous Crab. This crab shack serves up the day's catches in traditional spices that will make your mouth water!

With the droolies, juuuust before you vomit!

Has anyone ever NOT gotten sick there?

Still, it's soooooo good!

Aw, I miss that place...

Rue Altimore Restaurant

If you're looking for fine dining, be sure to take a stroll down to the Rue Altimore. The most elegant restaurant in town, it features both French and Italian cuisine, making it the perfect place for any celebration, from birthdays to graduations!

This is a LOW bar.

Sav-Mart

When you need groceries, you have a number of options in town, but the biggest place with the best selection is Sav-Mart.

Shop smart! Shop S-Mart! Classic!

Tony's Liquor Store

Here, Tony Sinclair and his family offer far more than just drinks, although there's plenty of that too, from cheap beer to fine whiskeys and everything in between!

Two Whales Diner

Two Whales Diner has been filling bellies in Arcadia Bay since it first opened in 1938. It's a popular hangout for both working folks as well as students. Its old-school flavor extends all the way to its working jukebox!

And for kids of the employees, who eat there for free.

I missed this place so much

Up All Nite Donuts

Most places in Arcadia Bay keep to regular business hours, but there's one restaurant that's open twenty-four hours a day, seven days a week. It's even open on Christmas morning: Up All Nite Donuts!

Best part about it? NO STEP-DOUCHE!

Right. Fuck the employees! Not like they have families or lives! They get to choose if they want to come in. They make that choice!

Privilege much?

19

Arcadia Bay Hospital

- Our emergency room is open twenty-four hours a day, as is our ambulance service.

- We are consistently rated as the ~~best~~ ONLY hospital in the county.

- We accept Medicare/Medicaid and most other kinds of insurance. *But if you're poor, fuck right off!*

Pro tip: Don't be poor. It solves soooo many problems.

Seriously, Victoria, how bitchy can you be? *ALL THE BITCHY!*

Arcadia Bay Hospital. The best place to be during your worst times.

I thought this was the state motto for Florida. *I like Florida.* *What, with all that sun and fun and surf and warmth? YOU WOULD!*

Places of Interest

Arcadia Bay Shore

One of the great draws of Arcadia Bay is our miles of shoreline, upon which crash the gentle waves of the Pacific Ocean. Besides giving us stunning vistas crowned each day with breathtaking sunsets, the sea provides us with some of our largest industries: fishing and crabbing.

The Arcadia Bay wharf is crowded with fishing boats. Most of these are operated by professionals harvesting food from the sea, but some are available for hire by people interested in deep-sea fishing or simply exploring the shoreline. You can even take a whale-watching cruise during the migratory seasons to watch those massive creatures make their way up and down the coast.

If you simply want to visit the shore, we have a number of public beaches available for you, many of which are wheelchair accessible and feature easy walks along the water. The most pleasant of these rest inside the sheltered bay from where our city takes its name, but you can explore the steeper shoreline beyond as well. Answer the ocean's call!

I actually kinda love the shore. I missed it. Puget Sound's just not the same.

YEAH, WELL... Fine. You got me.

HELLO, OCEAN!

'sup?

Arcadia Bay Lighthouse

The Arcadia Bay Lighthouse has stood watch over the city and the fishing boats that ply our nearby waters for well over a hundred years. You can reach it by means of a fifteen-minute walk up from one of our public beaches. This takes you up the backside of a sharp, seaside cliff that drops off into the ocean's waves far below.

Chloe, do you want to do the honors, or shall I?

The lighthouse itself is usually closed to the public, except on special days, but the land around it features picnic areas, hiking paths, and wooden benches on which you can sit and simply absorb the view. From the foot of the lighthouse, you can see all of Arcadia Bay sprawling out below you.

This makes it one of the most popular spots from which to watch our annual Fourth of July fireworks display. If you want the best seats, be sure to get there early!

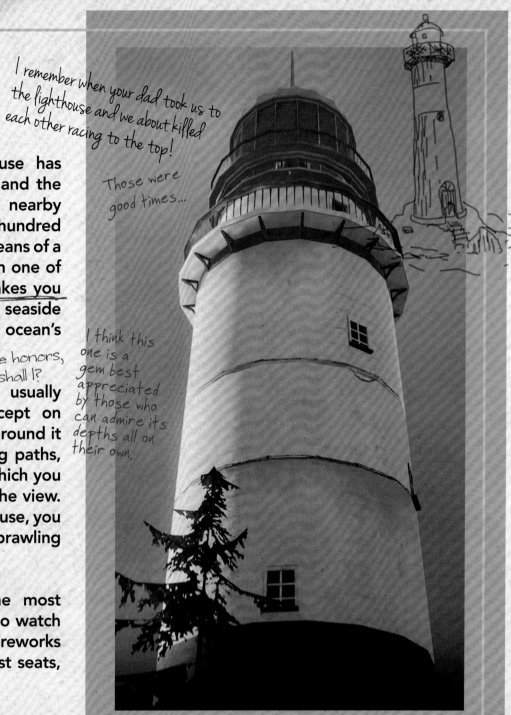

I remember when your dad took us to the lighthouse and we about killed each other racing to the top!

Those were good times...

I think this one is a gem best appreciated by those who can admire its depths all on their own.

Culmination Peak

Culmination Peak is the site of the original settlement founded by Ezekiel Blackwell and his congregation when they arrived in the area. From this, the highest point in the region, they could see all around them, all the way down to the Pacific Ocean. The Native Americans that called this land home long before them greeted them there and eventually invited them to join them in what is now the city of Arcadia Bay.

Today, Culmination Peak is the centerpiece of Culmination State Park. It features many miles of hiking trails and mountain-biking paths. People come from miles around to enjoy Culmination Peak, spending anywhere from a lunch break to weeks on end exploring its many delights. *Or, you know, spotting their lying cheat of a father meeting his old flame.*

Culmination State Park also has both rough campsites and ones with full hook-ups. If you plan to camp during the summer months, be sure to make a reservation ahead of time. The spots fill up fast!

And this is when it all turned to shit. Think about it! If the Native Americans had just driven Jeremiah Blackwell off—not killed him, just told him to politely fuck off—we could have been spared all of this.

You paint such a pretty picture...

Hey, it takes all kinds. Even unbelievable assholes.

Speaking of which, we should call Frank...

Overlook Park

Arguably the brightest spot in Culmination State Park is Overlook Park, the section of the state park that's closest to Arcadia Bay. This is a short drive up from the city itself, and city busses even make trips there regularly throughout the day.

Once you reach Overlook Park, be sure to take an easy climb into the foothills of the mountain, from where you can look out over the rest of the park. Be sure to find the statue of Ezekiel Blackwell (designed by noted artist Dwight Mueller) who stands there, commemorating our founder's adventurous spirit.

MESSAGE TO ARCADIA BAY CITIZENS!
FIRE DANGER!

I signed Evan's petition about this. Guess he knew his shit.

Most years we get plenty of rainfall in western Oregon, but we've had a bit of a drought over the past year. This has left a lot of our underbrush dry or dead, making for the perfect conditions for wildfires.

Watch for the signs stating the level of fire danger at any given time. When they are moderate or high, please restrict your use of fire in our parks so we can all enjoy them for centuries to come!

This is prophetic! To think that half the forest burned down after this was written. At the hands of some hooligans!

Right! Those damn hooligans! DAMN THEM!

I'll bet Nathan Prescott had something to do with it. Or Eliot Hampden!

Good choices!

Further Afield

There's always more to do in Arcadia Bay! Once you explore the shore, the parks, and our main street area, push yourself to explore a bit beyond. Here are a few of the hidden gems off our well-beaten paths.

Arcadia Bay Cemetery

It understandably might not sit at the top of your list of places to visit, but the Arcadia Bay Cemetery is a wonderful place to learn more about the history of Arcadia Bay, frozen in moments in time. It's also—not coincidentally—a quiet and private place, perfect for moments of solitude or silent reflection, whether for yourself or the people laid to rest there.

The Arcadia Bay Cemetery is set up in the foothills of Culmination Peak, with a wonderful view of our spectacular shoreline. It features the final resting place of hundreds of our former residents, including Ezekiel and Jeremiah Blackwell, and many of their extended families and descendants.

Visitors will immediately recognize the largest structure in the cemetery: a tall obelisk topped with a pyramid, in which sits a carved eye that watches over all of Arcadia Bay. This stands atop the mausoleum that houses the remains of our city's best-known philanthropists, the Prescott family.

I actually agree with this one. No better place to get stoned. A+++ Would smoke there again.

Do you think maybe you have a problem?

Why whatever do you mean, Maxine?

With drugs?

We got drugs? We got no problem!

So. That's a yes.

Shut up, Max.

What do you call a bunch of dead Prescotts?

What?

A DAMN GOOD START!

Arcadia Bay Golf Course

If you're looking to spoil a good walk, be sure to head over to the Arcadia Bay Golf Course to play a round of golf! This course is open to the public and features a full eighteen holes of fun that visitors will find both challenging and charming. *And people say that smoking dope is stupid... I don't get this world!*

When you're done, be sure to check out the Arcadia Bay Club House. They have some of the finest food in town, plus a well-stocked bar. The Club House is also open for private gatherings, including conferences, lectures, and weddings.

The Old Mill

Arcadia Bay has a long history of logging, stretching back to the city's founding. While we have a modern mill in full operation on the south side of town, the original mill built by the city's founders still stands in the woods below Culmination Peak.

For a long while, the Old Mill fell under the purview of the Arcadia Bay Historical Society, but once that organization downsized, the building fell even further into disrepair.

The Old Mill, as it's now known, has gone through several owners. At the moment, local entrepreneurs are exploring refurbishing it and repurposing it as a multi-use facility that can be employed as a restaurant, bar, or concert venue, among other things.

Translation: Became a shithole. Can't believe Damon turned it into a punk club.
Do you think he actually owned it? Or did he just take it? Same difference.

Damon's one scary guy. Wonder whatever happened to him...
Probably better not to ask?

Totem Poles

The people of Arcadia Bay have long had a close relationship with the local Native Americans. You can see this around town in the form of a number of totem poles that still watch over our city. These were carved by hand from the trunks of giant cedar trees, and some of them are well over a hundred years old.

One of the most famous examples of such totems stands on the grounds of the Prescott Dormitory at Blackwell Academy. The Topanga Totem, as it's known, is topped by a thunderbird, a creature of great power in many Native American myths.

In one such story, the bay itself was created by a thunderbird defending the shore from angry whales attacking the people there. The thunderbird picked up the whales, hauled them into the air, and dropped them from a tremendous height. The impact the whales made formed a crater into which the sea rushed, forming what we now know as Arcadia Bay.

Wild to think that these things the locals created hundreds of years ago are still watching over us today.

That's the power of art!

Art harder, motherfuckers!

Whoa! That's hella cool!

And yet we always side with the whales today. Why is there no Two Thunderbirds Diner?

Point.

The Water Tower

On the north side of town, you can spot one of Arcadia Bay's most enduring landmarks: the water tower. This tower has provided decent water pressure to the entire city ever since its installation in 1948, and despite its eccentric appearance, it does so to this day.

Shortly after the water tower was built, the high-school students in Arcadia Bay instituted a tradition of decorating its sides with graffiti of their own design. For the first several years, this caused great consternation to the city's government, which ordered the graffiti to be painted over immediately after every infraction.

Over the years, the sheriff's department quietly gave up trying to enforce this policy, as the students outnumbered the deputies and had far more time on their hands to plot their moves. Eventually, the city's mayor decided to unofficially allow the students to decorate the water tower as they saw fit—with the unspoken understanding that it would be repainted once a year in the late summer, right before school started up again. So, be sure to take a look at the water tower and enjoy the graffiti you see on it today, for it may well be gone tomorrow!

I love that the police just surrendered to the community's artistic needs.

And that it's basically a blank canvas for your graffiti. Well, yeah...

About Arcadia Bay

People who come to Arcadia Bay fall in love with it and never want to leave. Here are some of the wonderful reasons why.

With only about 5,000 people in town, you can always find your friends, no matter where they might be. On the flip side, it's hard as hell to get away from your foes.

Mayor Libby Cochran has held her post as our city leader for over twenty years.

Our Kiddie Costume Parade has kicked off our Halloween Bazaar in downtown Arcadia Bay for over two decades. This always takes place either on Halloween or the last Saturday before the holiday, from 9 AM to 3 PM.

I LOVED THIS! Were we ALWAYS pirates? I mean, we must have gone as something else one year, right?

SHUT YOUR MOUTH!

Local fisherman **R. J. MacCready**'s family has been working the shores of Arcadia Bay for three generations aboard their ship, the *Bali Hai!*

Ha! I know this guy. I think he has a thing for my mom... Couldn't be worse than David, right?

Novelist Ken Kesey, author of *One Flew Over the Cuckoo's Nest,* often visited Arcadia Bay.

My mom has a picture with him. Neat dude.

Arcadia Bay residents have a long tradition of using **vanity license plates** on their cars. On a per-capita basis, we have more than any other city in the nation!

FKN WLD!

Arcadia Bay once had a **passenger rail service**, but our railway station closed down in 1972. Trains still roll through town on a regular basis, carrying away lumber from the local mill.

And, judging by the graffiti we found in that train car, loads of hobos. Fellow travellers, Chloe. Fellow travellers.

Arcadia Bay is a **bird-watching paradise!** Birders come from all around the region to spy species of all sorts taking wing on the winds rushing through our town.

Arcadia Bay has its own small police department. However, most **law enforcement** in the area is handled with the assistance of the **county sheriff's department**.

A number of local businesses, including **Blackwell Academy**, have started a new program to hire honorably discharged members of our **armed forces** whenever possible.

The last **total solar eclipse** we saw in **Arcadia Bay was in 1979. Our next one isn't scheduled until 2169!**

Is that fair? We won't have a single one in our lifetimes!

Yet another reason to get out of here - to find someplace that will...

There are dozens of places named Arcadia, even in just the United States, but **there's only one Arcadia Bay!**

JUNK WANTED!

Need to make space for your **new stuff?**

Then toss it my way!
I can't believe you got that thing running.

Bring it down to

It's amazing what a bored teenager with unlimited time can manage...

American Rust

where your trash is **our treasure!**

We pay cash money for **good junk!**

We turn your scrap into **gold!**

That's what Nathan's dad said...

FUCK YOU, PRICE!

STOP

For more

Su

SAVE THE
WHALES

ne National S Lifeline at

3-TALK

texting +1741.

w you can help, please visit ALI rg

The Student Guide to Black~~HELL~~well Academy

B W Blackwell Academy.

Chloe! I can't believe you wrote all over this book!

Me? What about you, Max Caulfield?

I'm not Max! (You started it!)

I'm not the only one who wrote in this book. (So what if I did?)

Won't you get in trouble for this too, CHLOE PRICE ?

For defacing a book? GET TO THE BACK OF THE LINE!

You really should treat your things better.

It's not my book anymore...MAX.

HELP LOST !!

A college-preparatory high school in Arcadia Bay, Oregon, leading students toward excellence in the sciences ~~and~~ farts.

Such highbrow humor, Chloe

We go with our strengths, Rachel

So, since I obviously can't return this to the school library I suppose I should just WRITE ON EVERY PAGE OF THIS BOOK, huh?

That's the spirit! You go, girl!

2010 Edition

TITAN BOOKS

To my wife Ann, and especially
to my kids, Marty, Pat, Nick, Ken, and Helen, who loved
Arcadia Bay so much, that they insisted I visit.

ISBN: 9781785659355

Written by **Matt Forbeck**
Edited by **Matt Ralphs**
Designed by **Amazing15**
Screenshots by **Pat Forbeck**

Think they got enough Matts here?

*Corrections and commentary
by Chloe Price
And Max Caufield*

Do these people even exist? Have you ever seen them around Blackwell? Or even in town?

*Discovered by Victoria Chase.
And I am so telling on you bitches!*

What, you think Principal Wells just made them up? To make Blackwell seem much more important than it actually is? That would be pretty pathetic.

You don't have the guts

*Just saying...
That's a lot of Matts...*

DONTNOD / LIFE IS STRANGE
Life is Strange original story and characters created by
Jean-Luc Cano, Raoul Barbet and Michel Koch
Life is Strange game directed by Raoul Barbet and Michel Koch
Written by Christian Devine
Art Director: Michel Koch
Lead Concept Artist: Edouard Caplain
Concept Artists: Frédéric Augis, Florent Auguy, Alexis Bauzet,
Alysianne Bui and Gary Jamroz-Palma

DECK NINE / BEFORE THE STORM
Vice President: Jeff Litchford
Chief Technical Officer: Mark Lyons
Before the Storm game directed by Webb Pickersgill and Chris Floyd
Produced by: David Hein
Written by: Zak Garriss
Concept Artist: Andrew Weatherl

The publisher would like to thank Claudia Leonardi, Andrew James, Scott Blows,
Jon Brooke and Roxane Domalain for their invaluable help with this book.

To receive advance information, news, competitions, and exclusive offers online, please sign up for the
Titan newsletter on our website: www.titanbooks.com

Did you enjoy this book? We love to hear from our readers. Please e-mail us at: readerfeedback@titanemail.com
or write to Reader Feedback at the above address.

Contents

EVERYBODY LIES!!! *Liar!*

How much of a dick does a man have to be to make me feel sorry for NATHAN?

Even after he shot you?

Wrong timeline, baby! Or so you say...

What IS the language of photography? Kodakian? *Polaroidish, I think...*

Ditch school ☑ *Find Frank* ☐ *Get high* ☐

(Does that joke ever get old?) *think we're there already.*

Spoilsport! BLACKHELL! WE'RE IN BLACKHELL! I HAD A SCHOLARSHIP TO BLACKHELL! I ESCAPED BLACKHELL!

Starring ME! *Could you be any more desperate for approval?*

Point for me, I think.

Fair...

Welcome to Blackwell Academy

A greeting from Principal Wells to all students of Blackwell Academy.

Here at Blackwell Academy, we have a long tradition—one that stretches back for more than a century—of preparing some of the best students in the country to become some of the best people in the world.

If you graduated from here, you already know that. You're one of us.

If you recently matriculated: **Welcome.** *Gooble, gobble! Gooble, gobble! We accept you! We accept you! One of us! One of us! Freak....*

You might think you've already achieved a great deal simply by being admitted to our hallowed halls—and you have—but that is not the end of your time with us. It is but the beginning.

Ah, someone who appreciates the classics. ☺

Bigger challenges face you, both here and at college and beyond. We'll work with you to make sure you're prepared for that.

And let me tell you, if you're considering joining us at Blackwell, this school is not for the faint of heart. It's impossible to make great adults from mediocre children. We want students who expect nothing but the best from themselves.

Don't disappoint us. We won't disappoint you.

Principal Raymond Wells

Principal Raymond Wells, Blackwell Academy

A Special Message from Academy Benefactor
Sean Prescott

Dear Blackwell Academy Student,

A.k.a. Farty Barty!

Grow the fuck up...

The Prescott family has been a part of Arcadia Bay since my ancestor Bartholomew Prescott ventured out here to gaze upon the shores of the Pacific before Oregon was even a state. He immediately fell in love with this secluded little bay and decided to help found a town here that he and his progeny could all be proud of, and from where they could live in harmony with their neighbors.

That notion of a harmonious community has continued unabated

since then, and is the reason for our undying support for Blackwell
Academy. My great-grandfather, Martin Prescott, helped Jeremiah
Blackwell found this school, and I'm proud to say that we now have
our fourth generation of Blackwells attending classes there.

Too bad he's going to flunk out and disappoint everyone in the family all the way back to great-great-grandpa... You bitch!

Blackwell Academy is one of the things that makes Arcadia Bay the
truly special place we've molded it into over the past hundred years.
Without it, this would be just another beach town along the Oregon
coast. But with it, Arcadia Bay is a jewel that truly shines.

Join us here. Then you can shine too.

Shine on you crazy diamonds!

Blackwell Academy was founded by our namesake, Jeremiah Blackwell, who was born and raised here in Arcadia Bay. Jeremiah's family sent him to the Philips Academy in Andover, Massachusetts, where he graduated with honors. Afterward, he attended Harvard and graduated *cum laude*, but his heart always remained in Arcadia Bay. *This seems medically impossible.*

"The sound of the waves crashing against the shores I played on as a child always called me back," Jeremiah said after returning home to help run his family's business. "I feel it is a sincere tragedy that something as important as school ever had to draw me away."

To ensure the same fate never befell his children—as well as those of his neighbors—Jeremiah set out to found a school that could rival the top academies back east for their excellence. In 1910, the Blackwell Academy opened its doors to its first students, and it wasn't long until it became recognized far and wide as the educational jewel of the Pacific Coast. *F+ for that!* *Hey, I like it here.* *You would...*

In this special year of 2010 we celebrate our school's centennial with the help of five generations of students. As we do, we choose not only to look back at all we've accomplished, but also to set our sights on the future—and what triumphs still remain ahead.

In the words of Jeremiah Blackwell: "If knowledge is power, then schools are dynamos." The Blackwell Academy's goal is to charge you up until you are crackling with skills and information—and then set you loose on the world to make great things happen.

Come join us. We'll power you up. *You think that's how you got your superpowers, Max?*

They hand them out at registration these days.

Best place to sit
and think in the whole quad...
as long as you keep an eye out
for Brooke's drones.
A great place to get quarters
for the vending machines.

I think I learned more playing
RPGs with nerds out in the quad
than I ever did in class. Role on,
you crazy icosahedrons...

Where's the pigeons shitting on his head?
Must've Photoshopped them out...

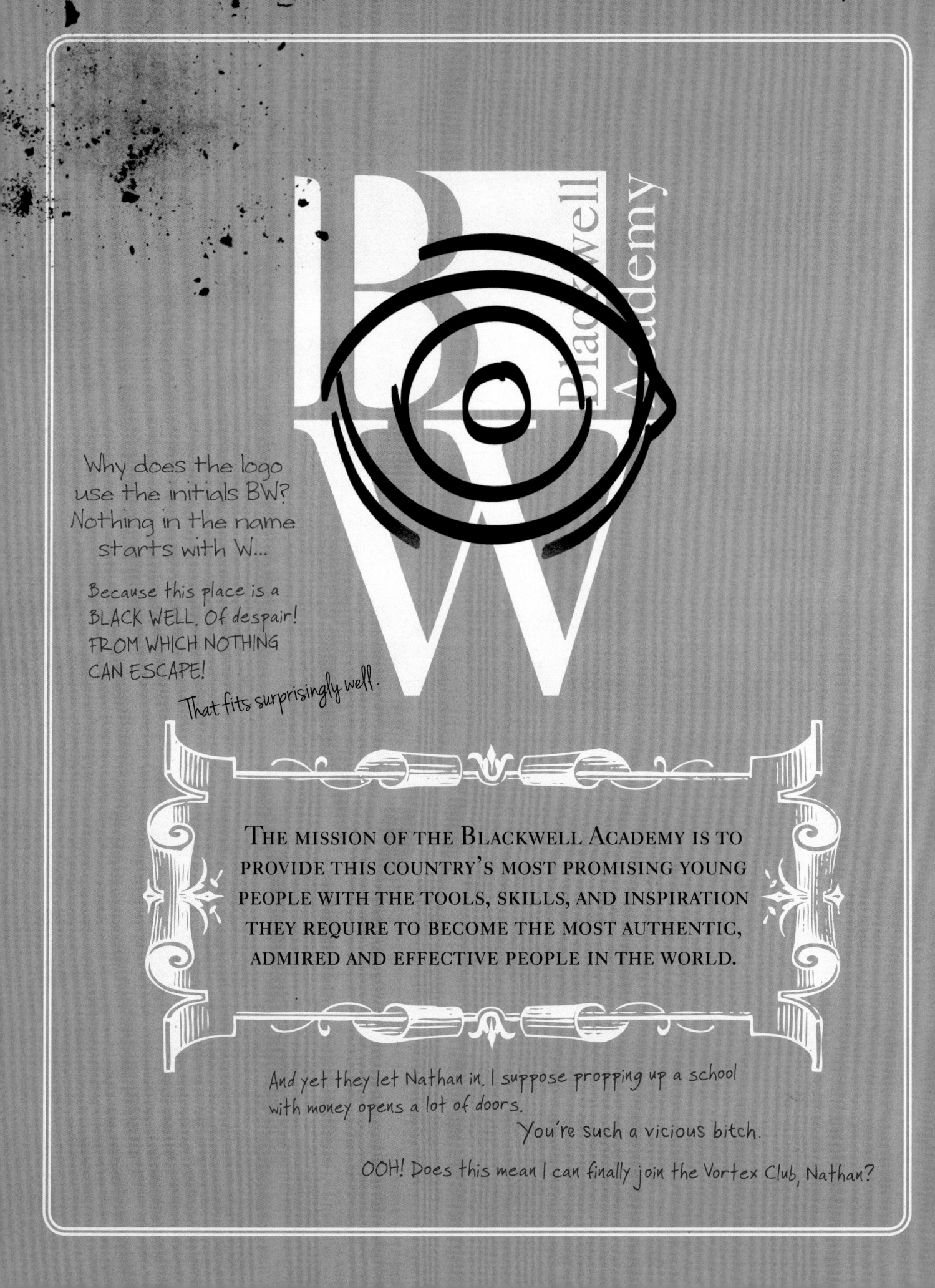

Why does the logo use the initials BW? Nothing in the name starts with W...

Because this place is a BLACK WELL. Of despair! FROM WHICH NOTHING CAN ESCAPE!

That fits surprisingly well.

THE MISSION OF THE BLACKWELL ACADEMY IS TO PROVIDE THIS COUNTRY'S MOST PROMISING YOUNG PEOPLE WITH THE TOOLS, SKILLS, AND INSPIRATION THEY REQUIRE TO BECOME THE MOST AUTHENTIC, ADMIRED AND EFFECTIVE PEOPLE IN THE WORLD.

And yet they let Nathan in. I suppose propping up a school with money opens a lot of doors.

You're such a vicious bitch.

OOH! Does this mean I can finally join the Vortex Club, Nathan?

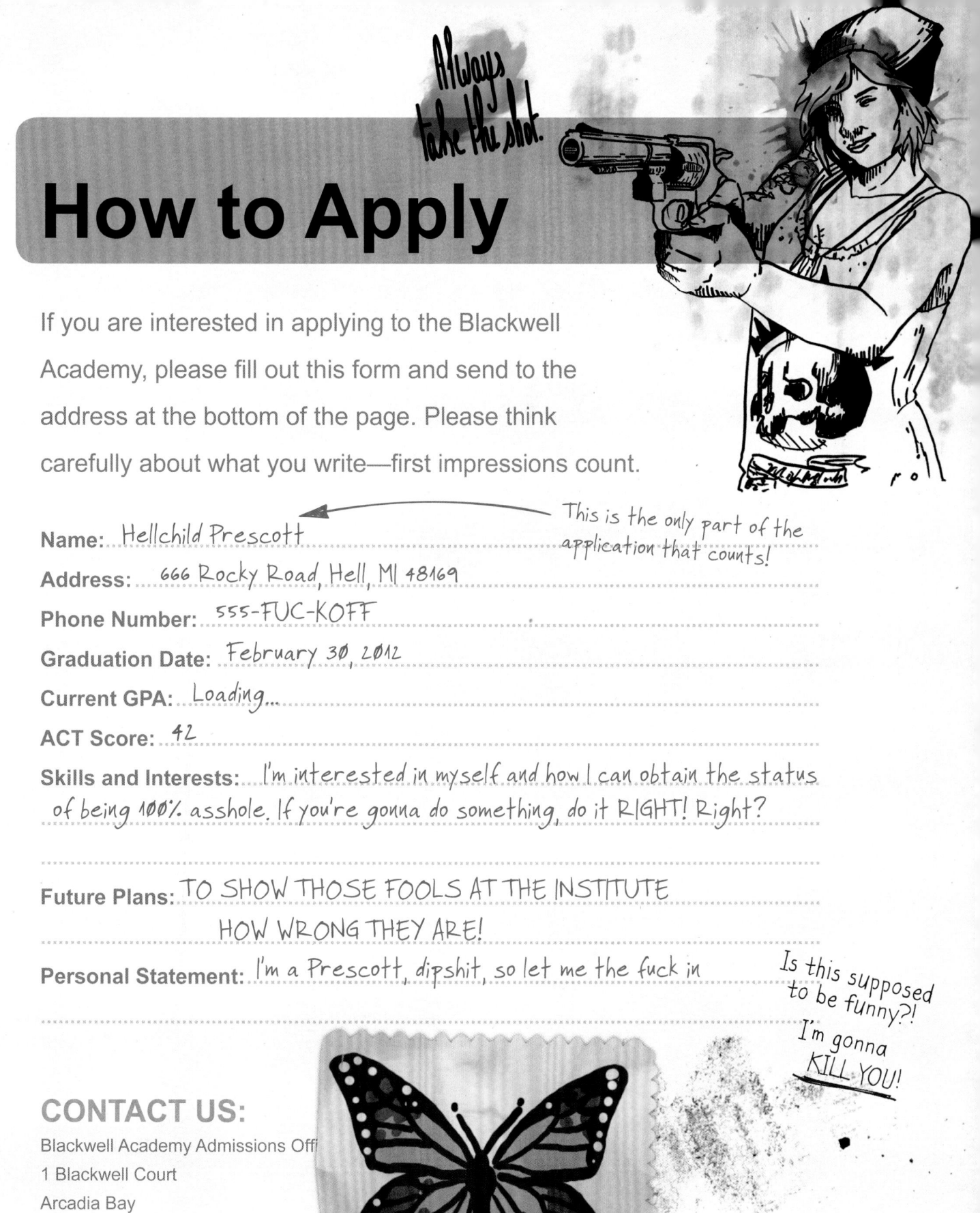

How to Apply

Always take the shot.

If you are interested in applying to the Blackwell Academy, please fill out this form and send to the address at the bottom of the page. Please think carefully about what you write—first impressions count.

This is the only part of the application that counts!

Name: Hellchild Prescott

Address: 666 Rocky Road, Hell, MI 48169

Phone Number: 555-FUC-KOFF

Graduation Date: February 30, 2012

Current GPA: Loading...

ACT Score: 42

Skills and Interests: I'm interested in myself and how I can obtain the status of being 100% asshole. If you're gonna do something, do it RIGHT! Right?

Future Plans: TO SHOW THOSE FOOLS AT THE INSTITUTE HOW WRONG THEY ARE!

Personal Statement: I'm a Prescott, dipshit, so let me the fuck in

Is this supposed to be funny?! I'm gonna KILL YOU!

CONTACT US:

Blackwell Academy Admissions Off
1 Blackwell Court
Arcadia Bay
OR 97141

Main Office: 555-630-8200
Admissions: Marianna Taylor — 555
Financial Aid: Lisa Avena — 555-630-8

USA 64

Endorsements and Recommendations

"A school like no other. A home like nowhere else."
Principal Raymond Wells, Blackwell Academy

"I fucking loved it!" Kurt Cobain

"I loved fucking it!" Amanda Fucking Palmer

Give the man a tampon. He's having his period!

"The only place for Prescotts. Period."
Sean Prescott, Prescott Industries

"Fat, dumb, and stupid is no way to go through life, son." Dean Werner, Faber College

"A place where students can explore the intelligence of science and the wisdom of the arts in both breadth and depth."
Travis Keaton, drama teacher

"A brilliant beacon of art, imagination and knowledge in a dark, cold world filled with ignorance."
Mark Jefferson, award-winning photographer

Wow! How'd they get a quote from him?!

I think Victoria offered herself up to him as tribute.

"I've seen things you people wouldn't believe." Roy Batty

Attack ships on fire off the shoulder of Orion. I watched C-beams glitter in the dark near the Tannhauser Gate. All those moments will be lost in time, like tears in rain. Time to die....

"The best four years of my life. I wish I'd never had to leave."
Marla Staples, Awww... **'94**

Don't tell me you're getting sentimental about this place...?

Just sad that this woman's life peaked so early.

"Nothing better prepared me for life—both here in Oregon and around the world—than Blackwell."
John Woods, '45

Our Successes

Students from

23
countries and

32
states.

And three planets!

42%
of students receive financial aid.

Because Blackwell charges too damn much. Poor much? Bitch much?

$$$$$$$$$$$$$
$$$$$$$$$$$$$
$$$$$$$$$$$$$
$$$

I hate that they make us sit sideways like that...

Average class size of

12

15
minute walk to the beach.

Graduation rate:

98%
Wait, am I the only one who didn't make it?

Surprise! (Not surprised)

Students admitted to college:

96%

Preparation for life:

100%
As corporate drones! Does that pay well?

Our Facilities

The Blackwell Academy campus is second to none, situated in a glorious forty acres of wooded lands on the far western edge of Arcadia Bay. From here, our students can gaze down over the town and onto the Pacific Ocean beyond. For several generations our students have gathered together at dusk to watch the spectacular sunsets herald the end of another amazing day at Blackwell Academy—and the promise of more to come.

Or, really, to blaze one out at 4:20. AMIRIGHT?

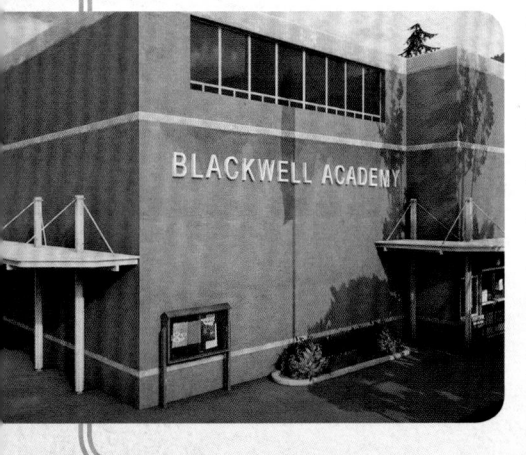

Originally, local Native American tribes lived in the area where *Suuuurrrr they did.* Blackwell Academy was founded. Unlike in other <u>parts of the</u> *Revisionist* country, they <u>lived in harmony here</u> with the earliest settlers, and *much?* you can still see traces of their influence upon our school to this day. Mostly in the way that our students, staff, alumni, and local community interact: with affection and respect.

If only the natives had stepped up and run these assholes off. Wonder what <u>that</u> timeline would be like?

Chloe! Think about it: a Prescott-free campus! A Prescott-less town! Wouldn't that be worth it?

*I love watching Justin grind these rails.
Is that a euphemism...?
What? NO!*

When your children come here, they become our children too. We care for them as if they were our own, living with and alongside us. *Creepy much?*
You prefer your own step-douche?
Fair point!

To our students, Blackwell becomes more than a school. More than just a set of handsome buildings set amid idyllic grounds in the temperate climate of the Pacific Northwest. And it's far more than just another spot on the map, another stop in their travels—Blackwell becomes a home, for all the years they spend with us. One where they are welcomed, cared for, and inspired. Here they can feel safe, protected—even loved.

More like a speed bump in our road race!

The foundation of that home is more than the spectacular stacks of brick that comprise our several wonderful buildings. It's constructed atop the values Jeremiah Blackwell laid down when he founded the Blackwell Academy. And those values never crack.

*Did he just say he values crack? ...
That seems right.*

GOOD LUCK SENIORS!!

Blackwell Grounds and Buildings

empty ←

The Grounds

While Blackwell is part of Arcadia Bay, it stands apart, both metaphorically and physically. The school itself is set back from the rest of the town, at the end of a cul-de-sac on Arcadia Bay's east side. It's surrounded on three sides by wooded parkland, giving it an exclusive, secluded feel while still allowing the students access to the charms of Arcadia Bay.

It's a dead-end school. JUST SAY IT!

It's French for 'bottom of the bag'. Kinda like you?

Fuck you very much.

On temperate days—of which we have many here on our protected slice of Oregon's tree-lined coast—the students spread out and relax in the many cozy areas planted around our isolated campus. Classes are often held outside so that students can drink in the smell of the pine trees carried on the fresh ocean breeze.

This could only be written by someone who hasn't been to the shore at low tide.

Hey, Little Ms. Suck-Up bagging on the town?

Oh, right, you only have eyes for Blackwell...

For those who wish to explore further, it's a short walk to reach the town. A school bus brings local students to and from campus every weekday, and municipal busses make regularly scheduled stops here all week long.

I.e. peasants.

I take it back. You're not <u>just</u> a suck-up. You just <u>suck</u>.

The Offices

Orifices (handwritten, with "Offices" crossed out)

The school's main offices are located right up front in our main building, and they are open to both students and parents from 8 AM to 5 PM every school day. Principal Wells' door is always open. Please feel free to stop in any time you like, although if you want to speak with anyone in particular and would rather not have to wait, it's usually best to make an appointment.

Right. I'll try to be more considerate the next time Principal Wells calls me down to his office. Appointments only!

After they punch your card ten times, isn't the next visit free?

Of course, we have staff available in our dormitory twenty-four hours a day, seven days a week while school is in session, and you can always reach someone there through the main line.

Prospective student tours are given every Friday, starting at 9 AM. Please call to reserve yourself a spot.

We should do them all a favor and show up to warn them off!

Like you're going to be up at 9 AM on a Friday.

Too true, Max. Too true.

Main Line: 555-630-8200
Principal: Raymond Wells—555-630-8210
Secretary: Eva Chu—555-630-8212
Career Advisor: Warren Hecht—555-630-8214
Security: Skip Matthews—555-630-8243
Custodian: Samuel Taylor—555-630-8233

Skip! I miss Skip! His name is one of my favorite verbs!

The Library

For generations, Blackwell students have enjoyed the chance to study in the Prescott Library in absolute luxury and (peace). It has proven itself over and over as a haven from the chaos of the world; a place where students can find the resources they require and the focus they need to further their research and their understanding of both their studies, and the world around them.

Because no one at Blackwell can read. How sad!
You're really useless, you know that?

The Prescott Library was originally comprised of the personal collection of books donated to the school by Jeremiah Blackwell himself. Fifty years ago, the Prescott family made another sizeable donation to the school in the name of Blackwell alumnus Harry Aaron Prescott.

This allowed us to realize Mr. Blackwell's original vision for the place by refurbishing it from top to bottom, and filling it floor-to-ceiling with the greatest books in the English language.

As illiterates, the Prescotts had no use for them in their own home. **Read this!**

Due to a subsequent and generous donation from the Prescott Foundation, we have recently outfitted the library with the latest in computers and information technology, putting the entirety of the world at our students' disposal. This includes access to several university databases and online archives. With such tools at their disposal, there's nothing our students can't do.

Proving her point

Do you really have to wind Nathan up like that?

I don't HAVE to. I WANT to. It's a moral imperative.

The Theater

daaaarling!!

It will come as no surprise to realize that with the emphasis Blackwell Academy places on the arts we have long been known for the events that take place in our theater, which is the largest such venue in our region. At Blackwell Theater we present performances of all kinds, including concerts, speeches, dances, and plays. Most importantly, we feature the burgeoning talents of our students, who put on events that stand shoulder-to-shoulder with those of the professionals who grace the country's stages.

In addition to our regular theater—which features seating for three hundred guests—we also have an outdoor venue where you can enjoy performances under the twinkling stars of the Oregon skies.

Blackwell Academy's students have put on plays and musicals of all kinds, under the direction of our drama teacher, Mr. Travis

Keaton. Over the past few years, these have included *As You Like It*, *The Crucible*, *Our Town*, *A Christmas Carol*, *You're a Good Man Charlie Brown*, *Beauty and the Beast*, and *Rent*.

This year, Mr. Keaton and the students are preparing a delightful performance of *The Tempest*, to be performed in our outside theater, just as Shakespeare's plays were when they debuted at the Globe Theatre in London in the 1600s. We look forward to welcoming students, parents, locals, and alumni to this special event.

Thank you so much for stepping up for this! We couldn't have done the play without you. *Don't mention it. Seriously. Ever.*

I can't believe you were actually on stage for this!

Ugh!

Just like when we would play pirates!

ARRGHH!

The Wellness Center

Parents and guardians: we know that one of the hardest things about having your children living away from home—even in an environment as wonderful as Blackwell Academy—is wondering what might happen if they become sick or hurt. While the main focus at Blackwell is education, making sure our students are happy and functioning individuals always comes first.

To that end, we have a full-time nurse on staff at our Wellness Center during school hours and on-call during nights and weekends. The Wellness Center has plenty of space for several students at a time to lie down, rest and recuperate during the times that they are unable to attend classes.

I feel like this all the time.

This is why you and An-Marie are on a first-name basis. That's just how I roll.

We also provide counseling services on an as-needed basis. For more difficult cases, we provide referrals to local psychiatrists. High school is a time in which many students struggle, and we believe in a proactive approach to offering them support.

When students need more medical attention than our staff can provide, we take them directly to the Arcadia Bay Hospital, where they can be seen immediately by the best doctors in the region. This is only a short ride from our campus, and a number of our students have volunteered as helpers there over the years.

And patients!

Nurse: An-Marie Barenchi—555-630-8220

Above all remember...

You are LOVED.

The Prescott Dormitory

When Jeremiah Blackwell first opened Blackwell Academy, the students were housed in the upper floor of the school. As the number of students grew, others found lodging in nearby homes. In 1945, the Prescott Foundation generously funded the building of a brand-new dormitory to house all of our students from out of town.

And for loser kids the Prescotts can no longer stand having at home.

You're just jealous, you can't afford it!

Not mutually exclusive, douche.

The accommodations in the Prescott Dormitory are second to none. All students have their own spacious room in which they can stretch out and enjoy total privacy. The dorm also features common areas—including bathrooms and lounges—where students can interact and enjoy excellent bonding moments with each other.

As long as you don't mind sharing a bathroom with everyone else in the place.

Hey, at least we don't share one with your step-douche.

I'm not totally sold on bonding moments in the bathroom, if I'm honest

While the Prescott Dormitory is co-ed, the floors are segregated by gender. Boys live on the first floor, and girls live on the second. There is a staff member on call in the building at all times.

You are not helping...

The Stadium

Despite Blackwell Academy's relatively small size, we manage to field several field sports teams, all of which play their home matches at the Blackwell Academy Stadium. This includes our boys' football, boys' and girls' lacrosse, boys' and girls' soccer, and co-ed ultimate frisbee team.

is the largest and best-kept secret in the Pacific Northwest: Bigfoot himself! Despite being camera-shy, he attends all of our home events to help root out our student athletes.

GO, BIGFOOTS!

So glad someone finally settled the greatest terminology argument of our time: Bigfoots or Bigfeets?

WHEW!

The bleachers around the stadium can comfortably hold several hundred fans, and they're regularly packed for our Friday night football games, played under the lights every Fall.

Ever seen one of these games? This is the loosest definition of 'packed' I've ever read.

While our swim team is known as the Otters, the mascot for our other teams

Packed to leave town immediately after the end of the game, maybe?

ARCADIA BIGFOOTS

The Swimming Pool

Sorry, guys, the WHAT? Just call it a pooooooool.

The newest building on campus is the Blackwell Academy Natatorium, which features an Olympic-sized swimming pool for the exclusive use of our students and staff. In addition to providing locker rooms for all of our sports teams and for our students in their individual athletic pursuits, it serves as the home to our conference-winning swim team: the Blackwell Academy Otters.

This... sounds... the opposite of sanitary.

Before the natatorium was built, the Otters regularly practiced in Arcadia Bay. While this is a beautiful setting in which to swim, the ability of the students to practice depended entirely on the weather. With the natatorium, the Otters—and the rest of the

Blackwell Academy family—can now swim whenever they like, any day of the year.

Since the natatorium features the largest single indoor space on campus, it also sees use for many other events beyond just swim meets. This includes celebrations of all kinds, even those at which no swimsuits are necessary! *Wait, did they mean...?!*

As long as you get Warren to 100,000% guarantee the security cameras are turned off, I'll show you some time!

Here is a showcase of some of the best photographs from one of our students, taken from an exhibition called 'Inhabitation'.

Never thought of the Old Mill as lonely. Nasty maybe? Filthy?

Strange to see it empty though.

When in doubt, find your nearest creepy barn and get to shooting.

Who took this??

Top tip, pop fans, these beams are NOT stable.

Yeah, photography's not worth dying over.

Scribbled like a true philistine.

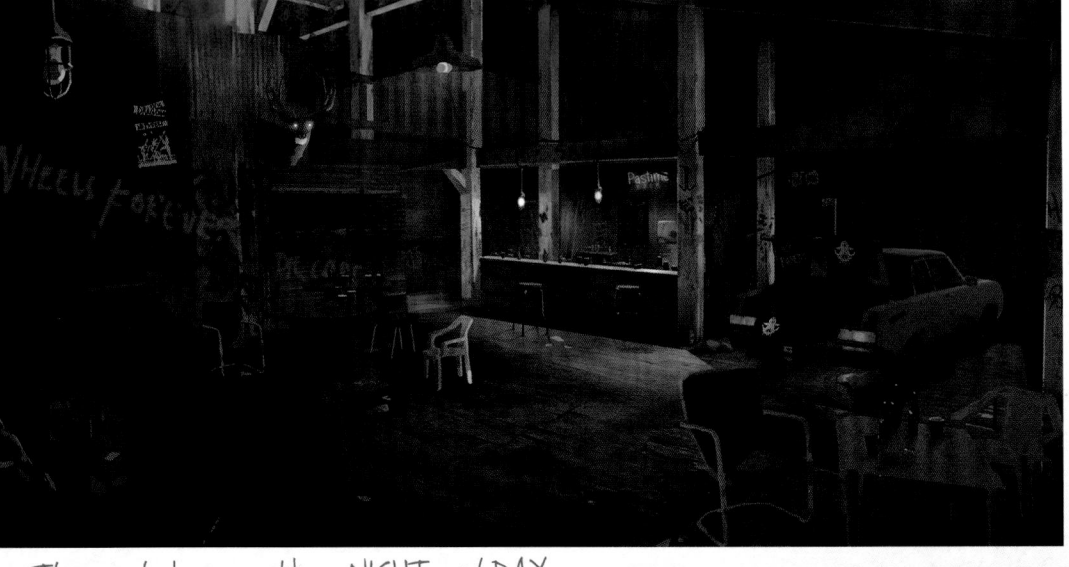

The exhibit was called 'Inhabitation'? For places that are entirely empty?

That's the point, right? Empty places are so damn lonely...

These photos are like... NIGHT and DAY.

I can see why the school wrestled SO HARD with the decision to throw you out.

Life at Blackwell Academy

Blackwell Academy Opportunities

At Blackwell Academy, our students are with us twenty-four hours a day, seven days a week, for the entirety of the school year. But our mission to educate them does not end in the classroom, nor when the school bell rings to signal the end of the day. While Blackwell Academy is our home base, we consider the world to be our classroom. *See? Dropping out only means you're getting ahead of the curve!*

While attending Blackwell Academy, students have the opportunity to strike out from our hallowed halls into adventures of their own, all under the guidance of Blackwell counselors. These limitless opportunities start right here in Arcadia Bay, but they also extend far beyond. *Maybe not the best solution... Don't let best be the enemy of skipping school.*

Welcome to Arcadia Bay. Now LEAVE! I actually came back HERE to go to school, so... The only boundaries are your ambitions and your imagination... *And a severe lack of cash...*

Venturing in Arcadia Bay

Within the borders of Arcadia Bay, students have countless chances to spread their wings and learn more about their local environs. Many of our students work in local businesses, gaining both in terms of pay and—more importantly—experience. This not only puts a bit of money in their pocket but also teaches them the important kinds of soft skills they will need as they emerge into the workplace.

And getting the absolute minimum in both! Here's an idea: become an entrepreneur. Go

To this end, we have set up a number of relationships with entrepreneurs around the area. At the start of every school year, we match our students up with the businesspeople we think will fit them best. *Like ~~Frank?~~*

into business for yourself! Find something people want (drugs), and sell it (drugs) to them! (drugs)

Do you have drugs on your mind, Chloe?
My mind? No. My pocket..?

It wasn't the school who matched me with him.

In addition to this, we have a program that matches students with artists and tradespeople in Arcadia Bay. These positions pay a nominal amount, but they offer students a chance to learn in conjunction with masters in their respective fields.

Similarly, we offer students the chance to work at the Arcadia Bay City Hall. There they have the chance to learn the nuts and bolts of American democracy at the local level. They can then take these lessons with them out into the wider world.

Such as: democracy—broken. Capitalism—broken. Your future—broken. So retreat back to a po-dunk town run by kleptocrats where you can tell yourself you're important by holding up a building permit for 72 hours.

Wow, bitter much? Go flip burgers in your mom's diner if you want to add something to the planet.

You know what, I will... TELL YOU TO FUCK OFF

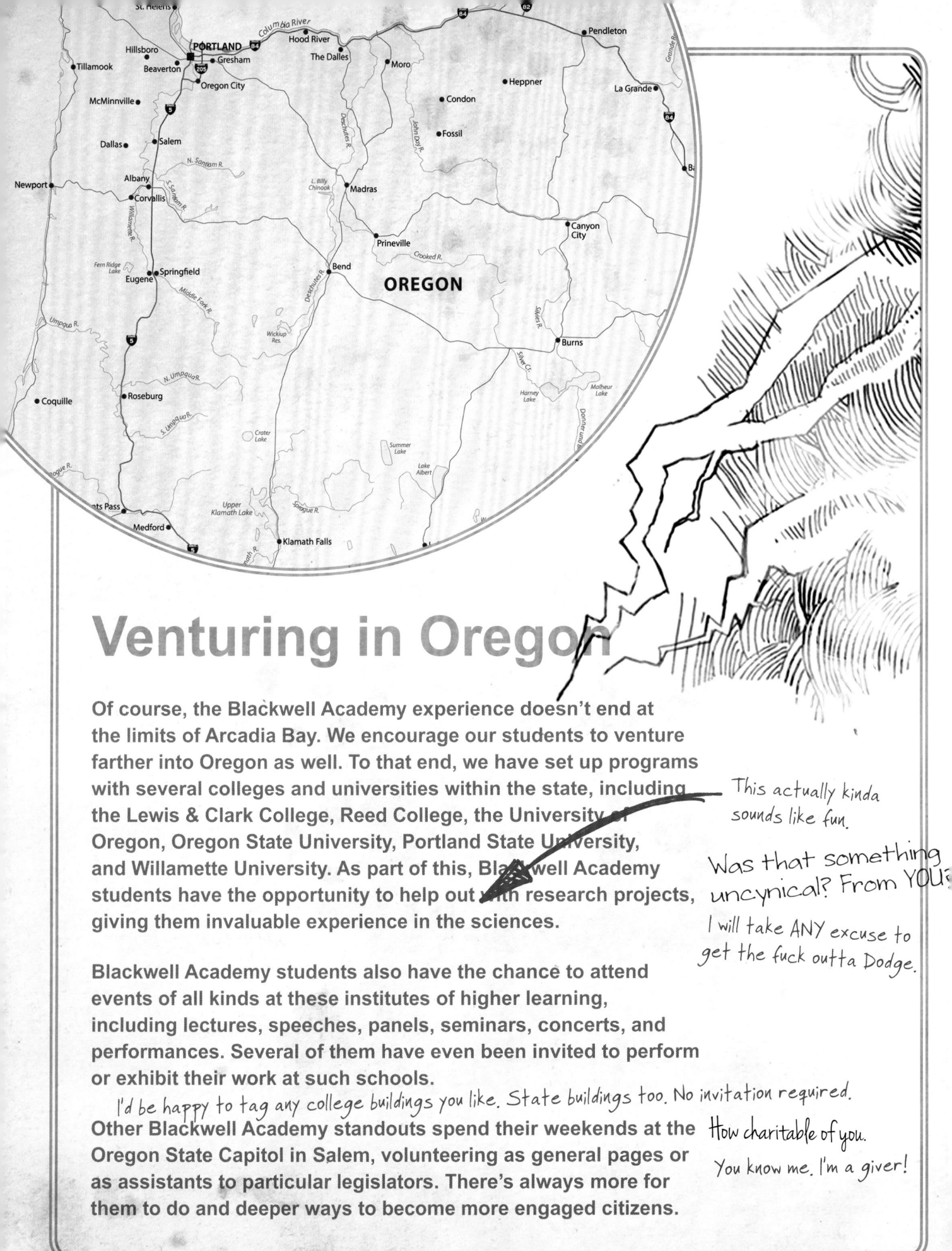

Venturing in Oregon

Of course, the Blackwell Academy experience doesn't end at the limits of Arcadia Bay. We encourage our students to venture farther into Oregon as well. To that end, we have set up programs with several colleges and universities within the state, including the Lewis & Clark College, Reed College, the University of Oregon, Oregon State University, Portland State University, and Willamette University. As part of this, Blackwell Academy students have the opportunity to help out with research projects, giving them invaluable experience in the sciences.

This actually kinda sounds like fun.

Was that something uncynical? From YOU?

I will take ANY excuse to get the fuck outta Dodge.

Blackwell Academy students also have the chance to attend events of all kinds at these institutes of higher learning, including lectures, speeches, panels, seminars, concerts, and performances. Several of them have even been invited to perform or exhibit their work at such schools.

I'd be happy to tag any college buildings you like. State buildings too. No invitation required.

Other Blackwell Academy standouts spend their weekends at the Oregon State Capitol in Salem, volunteering as general pages or as assistants to particular legislators. There's always more for them to do and deeper ways to become more engaged citizens.

How charitable of you.

You know me. I'm a giver!

Venturing Beyond

While we offer a spectacular education here at Blackwell Academy, nothing broadens the mind like travel. Jeremiah Blackwell himself would never have reached Arcadia Bay if his family hadn't ventured here from their ancestral home in Independence, Missouri. We expect nothing less from the students who carry on his legacy.

Except, maybe, drugs. **Chloe!** *Suuure, Little Miss Seattle. Some of us don't have the means to leave here otherwise.*

Most of our students come to Blackwell Academy expecting to spend all four years here. We do, however, encourage them to take a year or a semester abroad during their time with us. We prefer that they spend their freshman and senior years here in Arcadia Bay, as those years are so formative in their Blackwell experience, so most students that venture forth do so during their sophomore or junior years.

What about your truck?

I'm saving that for when they come after me with pitchforks and torches to chase me out of town.

Dropping out of school to stay stuck in Arcadia Bay does not equal a year abroad, Chloe.

Why don't you take a permanent vacation, Victoria? Pretty please, with a desperate dollop of validation on top?

We have special relationships with private academies in more than a dozen countries, including Brazil, China, Germany, Great Britain, India, Ireland, Italy, Kenya, Mexico, Qatar, Spain, and Sweden. If our students want to attend a school elsewhere, we always make a special effort to find them a temporary home away from their Blackwell home. We always make sure they come back to us, safe, sound, and smarter than ever.

Ha! They might as well call this the Unsolved Mysteries Academy.

I'd not thought about satellite academies just as messed up as this one. Man, there's a thought.

Dining Options

Most of our students live off-campus, but we feed all of them lunch every day at the Blackwell Academy Refectory. Students living in the Prescott Dormitory are served breakfast and dinner there too. The food is so excellent that Principal Wells takes his lunch with the students every day.

Sure, he takes it, but I don't think I've ever seen him actually eat the food. *He's a robot in disguise!*

When students have a craving for something nourishing at odd hours, Jeremiah's Joint—in the basement of the Prescott Dormitory—offers snacks and drinks, along with a quiet place to gather and study.

I - I can't. It's just too easy.

Glad to see you still have your pride.

Students looking for something different have all of Arcadia Bay open to them, just a short walk or bus ride away. Options range from greasy-spoon diners all the way up to high cuisine.

Doesn't your mother work at the Two Whales? Isn't that place named after the both of you?

She does. I hear your mother moonlights at the Lonely Cold-Hearted, Truly Pathetic Bitch.

POPCORN

Student Clubs

At Blackwell Academy, we encourage our students to explore their interests—academic and otherwise—by banding together with each other into clubs. Students can apply to form a club with a minimum of three members, and they immediately become officially recognized by the school.

sex, drugs and rock n roll!

Some of our clubs include:

I'm with Groucho Marx on this one. "I don't care to belong to any club that will have me as a member."

I suppose that kills off my plans for the American Rust Club...

Oh, nooo!

- Comics
- Chess
- Drama — *I swear, if it wasn't for this, I'd have left Blackwell already.*
- Gaming
- Gamer Guyz
- Geek Grrls Book Club
- French
- Photography
- Mathletes
- Sci-Fi Movie
- Students for Christ
- Vortex

You do seem to love your drama...
Just when you're in it!

You know why they call it the Vortex Club? BECAUSE IT SUCKS! Thank you, I'll be here all semester.

But there are many more. If you can't find one for you, just find a coupl friends and make your own!

BLACKWELL THEATRE Presents: CHEMYSTERY

WHAT'S ON T.V.?
i'm hungry
Let's play some vids

YOU'RE A SLOB
Where were you?
Let's talk

CHESS CLUB

The Blackwell Totem

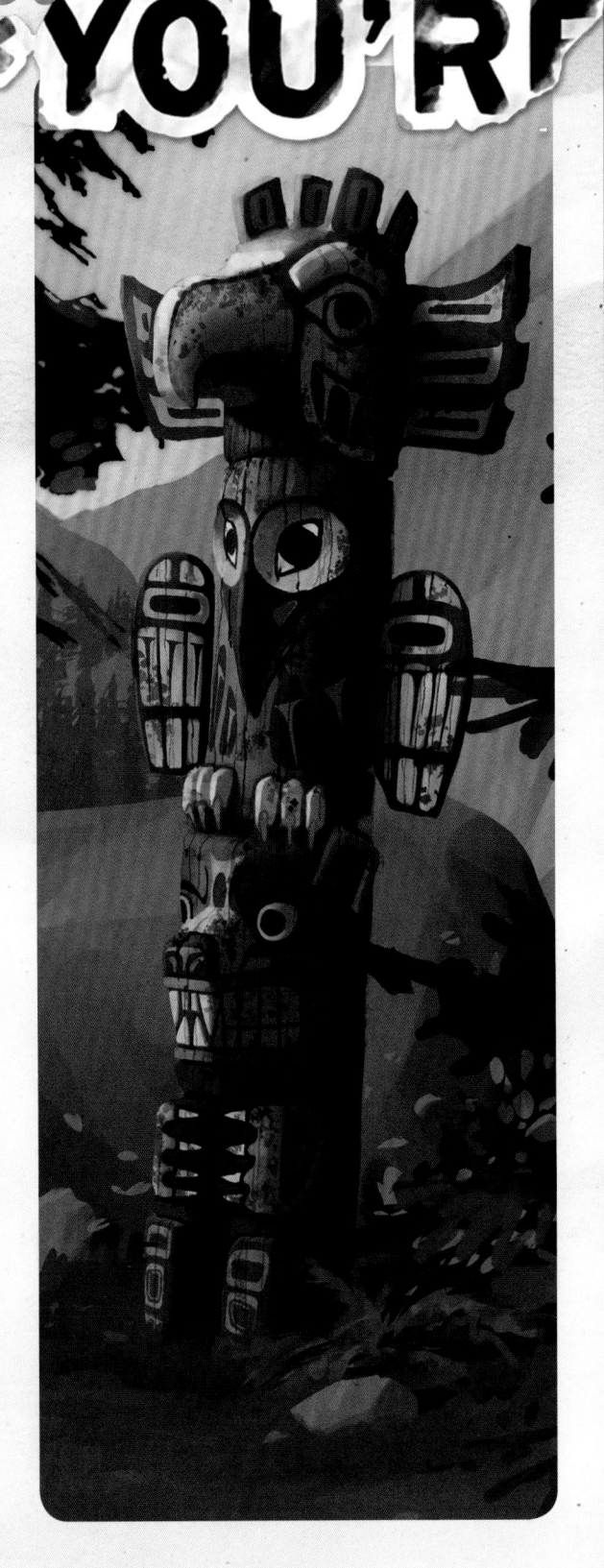

At Blackwell Academy, we encourage independent thought, and the foundation for that is independent journalism. To that end, we have supported a student-run newspaper—*The Blackwell Totem*—since even before the founding of our school.

Translated: sucking up to the administration.

I liked Juliet's expose of the Vortex Club. Exposing those assholes is something Principal Wells should be doing already.

Now I can't get that image out of my head...

While Blackwell Academy was founded in 1910, *The Blackwell Totem*'s motto reads, "The Spirit of the News Since 1898." That's because when Jeremiah Blackwell was starting to think about how to improve education in the region, he sponsored the *Totem* as a means of reaching out to like-minded students, parents, and educators. The *Totem* helped gather together such people to form Blackwell Academy's first student body.

So we have our school's rag to blame for this hellhole?

The power of the press! If there hadn't been a Blackwell, I might not have met you!

Ohhh, fine...

Named after the Native American totem pole that graces the lawn outside the Prescott Dormitory, the *Totem* continues to be an independent voice for Blackwell Academy's students to this day. This long-standing tradition likely explains the wide variety of newspapers that serve Arcadia Bay and its environs. Many of our student reporters have gone on to write for publications like *The Independent*, *The Arcadia Bay Beacon*, *The Arcadia Bay Gazette*, *The Bay Bud Weekly*, *The Great Northwest*, and *The Golden Gate Reporter*.

Student Government

At Blackwell, we have a student government that consists of one council with four positions: President, Vice President, Secretary, and Treasurer. Any student from any grade level is eligible to run for any position, although most are selected from upperclassmen.

The student council serves in an advisory role, bringing the concerns of the student body to our Principal. It's also involved in a number of fundraisers throughout the year that culminate in the presentation of the senior class gift to the school on behalf of our graduating students. You can see their contributions scattered around campus. *Ah, yes, yet another way for the school to milk more money out of our families rather than paying for the basics themselves!*

Our current student council members:

- President: Whitney Beltrán

- Vice-President: Ajit George

- Secretary: Cam Banks

- Treasurer: Richard Dansky

Right! Like the memorial park bench of 2009, the memorial scoreboard of 2006, and who could forget the memorial Port-A-Potties of 2001?

We owe that class so much.

Have you ever heard of any of these people? I had lunch with them last week.

Is there anyone here who doesn't love you?

Should there be?

Uber Présidente:
Chloe Price

Treasurer (hunter):
Max Caulfield

Campus Maintenance

We like to run a tight ship here at the Blackwell Academy. We keep our buildings and our grounds clean and in tip-top shape to make sure that they're here for even more generations to enjoy.

The leader of our custodial team is Samuel Taylor, who graduated from Blackwell Academy himself in 1978. Samuel has been a fixture here for over twenty years, and he takes great pride in keeping the academy grounds trimmed prim and proper, and its buildings in sharp order. If you ever have a concern with any of our facilities here on campus, Samuel is the one to call.

Such a creep!
The fact that you don't like him now makes him my best friend.
Tomorrow, I'm bringing him an apple.

The perfect gift from such a witch! You could maybe use some fiber yourself

Is this the career path for most Blackwell graduates?
Of course! I've already applied to be Samuel's assistant next year.

Custodian:
Samuel Taylor
555-630-8233

Campus Security

The first responsibility of any school is to keep its students safe, and we take that responsibility as seriously with your children as we do with our own. In addition to establishing a close relationship with the Arcadia Bay Sheriff's Department, we have a full-time security guard on staff whose sole job it is is to watch over our students.

Full-time means 40 hours a week, right? So who's watching us the other 128 hours each week?
You're restoring my faith in math...

Skip Matthews graduated from Blackwell Academy in 2003, and after pursuing a degree in music at the University of Oregon, he returned to become our Chief of Security. Under his watchful eye, we have had several incident-free years here at Blackwell Academy.

Aw, Skip. This is maybe the saddest sentence I've ever read.

The crime rate in Arcadia Bay itself is incredibly low. Students can walk the streets at any hour of the day and feel safe, and few residents bother to lock their doors. You can rest assured that your child will be safer here than anywhere else you might send them.

TELL THAT TO RACHEL AMBER!

I miss Skip. He rocked.

Had to be better than David Madsen, right?

My step-douche? I'd rather have Frank in charge...

Security:
Skip Matthews
555-630-8243

Blackwell Academy Student To-Do List

STILL 8-BIT

While we place a strong emphasis on academia here at Blackwell Academy, even the hardest-working students sometimes need a break. There are plenty of other things for students to do in and around Arcadia Bay while they're taking a well-deserved rest.

Explore our wooded acres!

Take a walk on our city's miles of sandy beaches!

Enjoy our city's parks!

And set fire to them! I'm <u>sure</u> that was an accident...

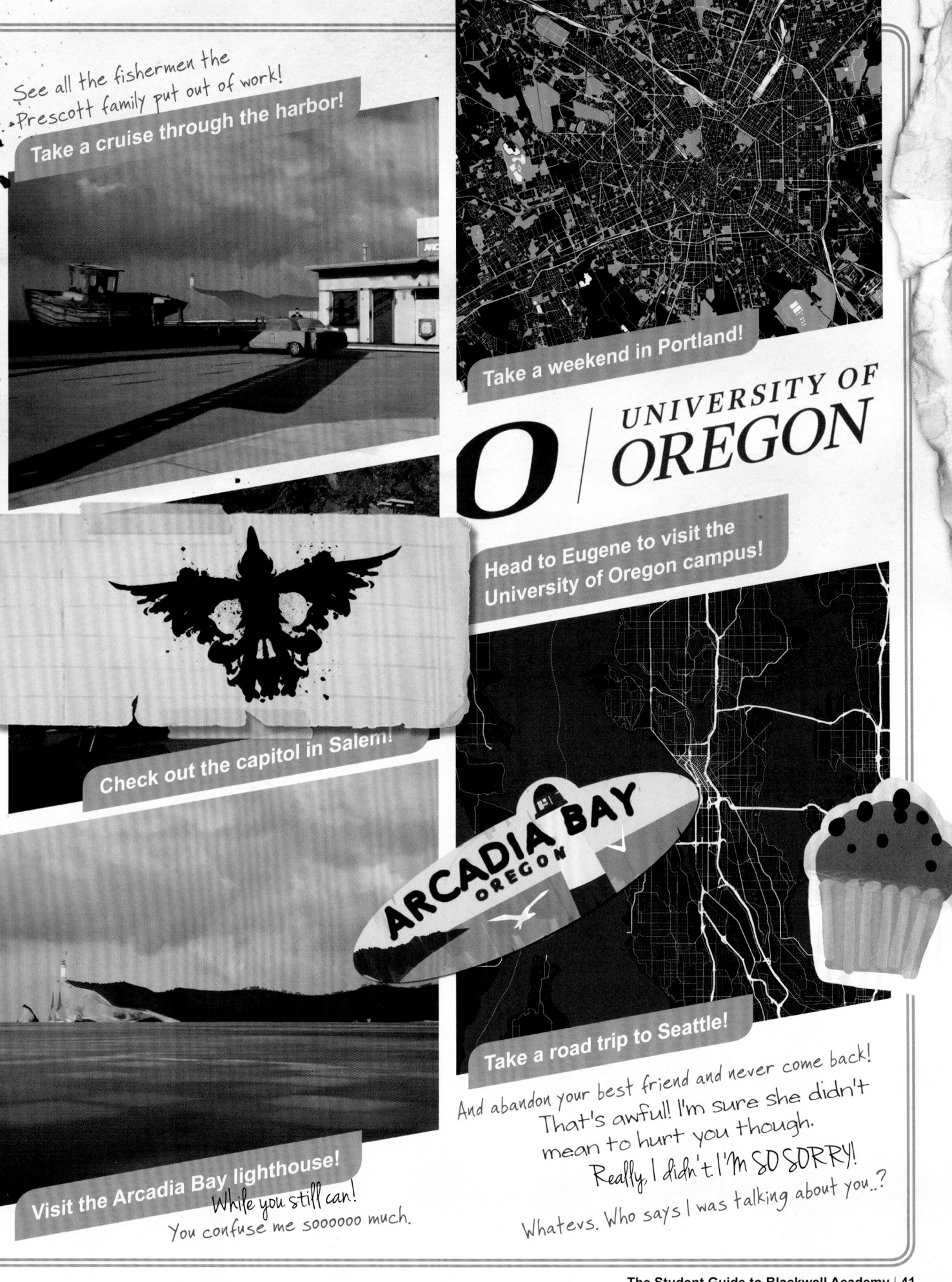

See all the fishermen the Prescott family put out of work!

Take a cruise through the harbor!

Take a weekend in Portland!

O / UNIVERSITY OF OREGON

Head to Eugene to visit the University of Oregon campus!

Check out the capitol in Salem!

ARCADIA BAY OREGON

Take a road trip to Seattle!

And abandon your best friend and never come back! That's awful! I'm sure she didn't mean to hurt you though. Really, I didn't. I'M SO SORRY!

Visit the Arcadia Bay lighthouse! While you still can! You confuse me soooooo much.

Whatevs. Who says I was talking about you..?

Meet the Teaching Staff

Principal Raymond Wells

Principal Wells proves just how invaluable a Blackwell Academy education can be. He graduated from our school in 1978. Twenty-five years later he left a wonderful job as the superintendent of schools in Boise, Idaho, to return to Arcadia Bay as the latest in our long line of distinguished principals.

FAVORITE QUOTE: "The only thing we have to fear is fear itself." *President Franklin D. Roosevelt*

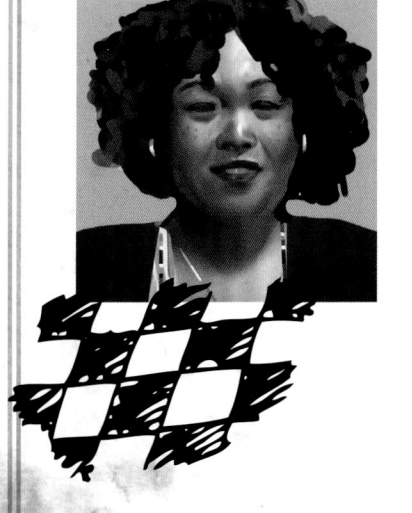

Michelle Grant (Science)

Ms. Grant comes to us by way of Howard University, where she graduated cum laude with dual degrees in both science and education. She taught in the Portland School District for several years before taking a job at Blackwell, where she quickly became well known for her encyclopedic knowledge of the local Native American history.

FAVORITE QUOTE: "Life is like riding a bicycle. To keep your balance you must keep moving" *Albert Einstein*

Juan Edwards (Physical Education)

Mr. Edwards graduated from Duke University and moved out to Oregon to pursue his Masters in Physical Education at Oregon State University. While studying there, he met a number of Blackwell Academy students. After he graduated he joined us as our new PE teacher and football coach.

FAVORITE QUOTE: "But man is not made for defeat. A man can be destroyed but not defeated." *Ernest Hemingway*

Challenge accepted!

Bernadette Hoida (English and Literature)

Ms. Hoida is an institution at Blackwell Academy. Having started teaching here over forty years ago, she is now beginning to educate her third generation of students at Blackwell, keeping them enraptured with her dramatic readings and her dynamic lectures.

FAVORITE QUOTE: "For there is so little time to waste during a life, what little time there is being so precious, that we must waste it, in whatever way we come to waste it, with all our heart." *Mary Ruefle* I think I need this as a tattoo.

If only you could afford one.
Money's the only thing standing between me and the world!

Travis Keaton (Drama)

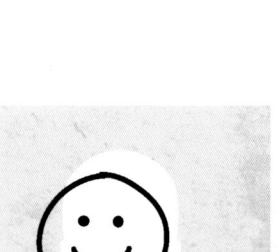

Once a Broadway star, Mr. Keaton gave up his career to settle down with his wife and newborn son in Portland nearly twenty years ago. He couldn't give up acting entirely, though, and was hired as the drama teacher at Blackwell Academy after being seen in a local production of Harold Pinter's *The Room*. He has been helping Blackwell students trip the limelight ever since.

FAVORITE QUOTE: *"Ars gratia artis."* **("Art for art's sake.")**

Have you ever seen this? It's, um, trippy.
I think I have enough trippy drama in my life.

Charles Cole (Art)

Mr. Cole had a burgeoning career in comic books or, as he likes to call it, 'sequential art,' but he put that behind him to concentrate on educating the next generation of artists. While he focuses primarily on illustration, he is also an accomplished sculptor, and his work is often displayed in galleries across the Pacific Northwest.

FAVORITE QUOTE: "The purpose of art is washing the dust of daily life off our souls." *Pablo Picasso*

Whoa! I hear he ghost-drew Batman for Bob Kane back in the '60s.
Exactly how old is he?
Dirt looks at him and says, "Dude, you're old!"

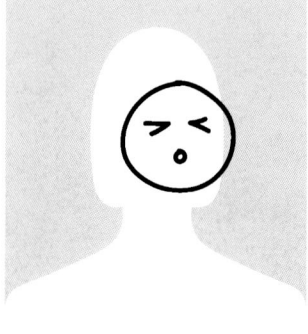

Ingrid Ferdinand (Physical Health)

Ms. Ferdinand was a professional basketball player for the WNBA team Portland Fire for all three seasons the team played. When it folded in 2002, she accepted an offer to take over as our new Physical Health teacher here at Blackwell Academy, and she's been with us ever since. In addition to her teaching duties, she coaches every one of the girls' teams in one capacity or another.

FAVORITE QUOTE: "I touch the future. I teach."
Christa McAuliffe

This is the one teacher I don't mess with. She could dismantle me with her eyebrows. Plus, she's hella cool. *Hella? Really?*

Percival Jackson (Social Sciences)

Before he joined us to teach History, Psychology, and Political Science, Mr. Jackson was originally a Blackwell Academy valedictorian. After graduation, he attended Yale, where he studied Ancient Greece, and thereafter spent several years in the Peace Corps in multiple locations overseas.

FAVORITE QUOTE: "It's dangerous to go alone! Take this."
The Legend of Zelda

I was wrong. THIS is the saddest sentence I've ever read. To go from valedictorian to high school teacher? Gah! *There are worse places to end up than Arcadia Bay.* *Name one!*

Eleanor Terry (Practical Math and Life Skills)

Ms. Terry spent her formative years in her native England, studying the practical applications of live-action roleplaying exercises (known as LARPs). She wrote her doctoral dissertation on the efficacy of such games in teaching experiential learning, and here at Blackwell Academy, she puts her theories to excellent use.

FAVORITE QUOTE: "Life is a song—sing it. Life is a game—play it. Life is a challenge—meet it. Life is a dream—realize it. Life is a sacrifice—offer it. Life is love—enjoy it." *Sai Baba*

Did you ever LARP? *I'm not that emo/goth.* *Dodge questions much?* *IT WAS JUST ONCE. OBFUSCATION!*

Course Focus: Drama & Theater

The World's A Stage

by Travis Keaton

This is my beloved career, which I chose and adore mostly for the fresh perspectives it gives me on the dramatic presentations to which I have dedicated my entire professional life.

I love the theater. I love the stage. And I love sharing that at every turn—not just with audiences and fellow enthusiasts, but even more so with students.

Mr. Keaton rocks! *Drama much?* *Do you not love drama? It's just so... dramatic.*

It's one thing—an absolutely amazing thing—to be entrusted as a teacher with the hearts and minds of young people at their most precious and impressionable stage. Just at the dawning of their adulthood, when they are stepping out from their homes, learning who they are in the moment and charting out who they want to become. This is such an honor, one for which any teacher could only strive with all their might, every day and every night, to be worthy.

It's something else entirely, though, to be able to take those same students out of the classroom and have the opportunity to put them on the stage. To place them in that magical, lime-lit circle in which no limits hold and everything is possible. A place where they can explore the greatest themes of literature by plumbing the depths of their very shallow souls.

Must you piss on everything?
I got two words for you: TEA ROOFIE.
You incredible bitch!
She thinks I'm incredible! It's love! TWUE WUB!

TEA ROOFIE!
TEA ROOFIE!
TEA ROOFIE!
TEA ROOFIE!
TEA ROOFIE! TEA ROOFIE!
TEA ROOFIE!
TEA ROOFIE!

This is when literature becomes life. When the actors breathe life into the text and make it thrive to near-bursting with meaning and intent. When the world shrinks down to inhabit a single stage for a single night and tell a single story that means everything.

At Blackwell, it is my privilege to share this experience with our students. To guide them along their way as they discover the power of inhabiting the roles of others. In this way, they not only examine the humanity of the characters they play but scrutinize their own.

Could you ask for anything more luminescent? More incredible? More magical?

There's always drugs... SHHHH! Just sayin'...

Especially when we have the chance to explore the Bard's works in loving detail. When we can expend an entire school year dissecting and deboning his oeuvre. This is what high school is made for!

Have any other playwright's works been tripped across so many boards? Has any other scribe's works played across so many lips? Has any other canon of work so exposed the soul?

Does that sound painful to anyone else? Is it just me?
Yes. And you will die forgotten and alone for it. Who are you again?

If you care to share in this experience with us, please set aside some time in your busy schedule to witness our production of *The Tempest*.

I still can't believe you subbed in for this. Thank you SO MUCH!
Don't mention it. Please. Ever. Again.

We will be performing the play for one night only: Saturday, May 8th, 2010. Weather permitting, we will make use of our outdoor venue, playing at greatness under the ineffable stars. Otherwise, our performance will grace the stage of the Blackwell Academy Auditorium.

We hope you can join us for this magical, soon-to-be-legendary night.

Full of legendary fuck-ups for sure... Well, Nathan—which is the same thing.

Travis Keaton, Head of Drama

Choose Blackwell Academy

89% of Blackwell Academy students are accepted into one of their top three college choices.

I got into NONE OF THE ABOVE, so yeah, that checks out!

Average number of AP credits Blackwell Academy students enter college with:

15

Number of sports at Blackwell Academy:

12

Number of clubs at Blackwell Academy:

23

That's, like, 23 too many...

Number of students required to start a club at Blackwell Academy:

3

Number required to give a shit: ZERO! Hey, if we add another friend, we could form our own club!

That's so sad... *Fuck, I miss her.*

I CAN'T SLEEP

Average GPA of graduating Blackwell Academy students:

3.5

This is what you're here for, Max. To make up for my slacking!

Average ACT score of Blackwell Academy students:

30

You're asking an awful lot of me, Chloe...

Average SAT score of Blackwell Academy students:

1325

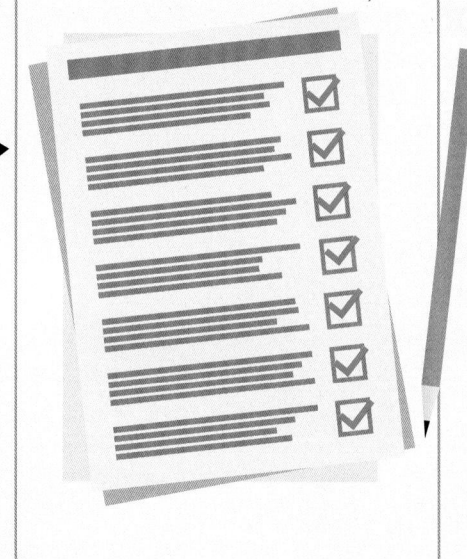

Number of lifetime friends made at Blackwell Academy:

Countless!

Math is clearly not their strong suit here. Good thing you came here for the arts!

ShOOSH I'm dreaming

Educational opportunities at Blackwell Academy:

Limitless! ∞

Student Profiles

Introduction

The best way to get to know a school is to get to know its students. While the faculty and staff might be here for far longer than any student, the teenagers in any school far outnumber the adults. They color the Blackwell Academy experience as much as anyone else, if not far more.

That's right! WE CAN TAKE THEM!

With the permission of our students and their parents, here are profiles of some of the most prominent and involved members of our student body. They came here to Blackwell Academy from all sorts of places and for all sorts of reasons, but you'll find that the unifying cause for being here is a desire to improve themselves through education.

We concentrated mostly on younger students in these pages, because they are literally the future of Blackwood Academy. New students who join us here next year will herein have the opportunity to get to know these classmates before they even step foot on campus.

It's like a stalker guidebook!

So, like Facebook on paper.

Exactly!

Rachel Amber

Seriously, I miss her so much. I can't believe she's gone.

We'll find her. She's gotta be out there somewhere.

HOMETOWN:
Arcadia Bay, Oregon

SPORTS:
None

CLUBS:
Drama Club

HOBBIES:
Music, acting, fashion, modeling

LIVES:
Off-campus

POST-BLACKWELL PLANS:
To travel the world and find my place in it! I hope to move back to the Los Angeles area and work my way through college as a model and actress.

WHERE ARE YOU FROM?
Originally I'm from Long Beach, California, but my family moved to Arcadia Bay a while back. I miss California a lot, but my father is the District Attorney here in Arcadia Bay, so I think we're here for the duration.

And raging asshole. *That's...fair.*

WHY DID YOU COME TO BLACKWELL ACADEMY?
It's by far the best school in the region. Probably the entire state. The fact that it's a short drive from our house is incredibly convenient, but I'd probably have gone here even if that wasn't the case. It's one of the best parts of living in Arcadia Bay.

You are such a suck-up.
Doesn't mean it isn't true.

So you want to live here forever?
Fuuuck no.

WHAT IS YOUR FAVORITE THING ABOUT BLACKWELL ACADEMY?
The teachers here are fantastic. They're so sharp and smart, but they're also supportive and kind. If only every school in the world could have such amazing people in it, think about how wonderful that would be.

QUOTE: "Vote James Amber for District Attorney!"

Chaos

Victoria Chase

HOMETOWN:
~~Seattle,~~ Washington

SPORTS:
Swimming

CLUBS:
French,
Photography,
Vortex

HOBBIES:
Fashion,
travel

LIVES:
Off-campus

POST-BLACKWELL PLANS:

I still have to decide if I want to attend one of the Ivies or Sarah Lawrence, or maybe even the Fashion Institute of Technology. Once I graduate from any of those, I plan on moving to Paris and pursuing a career in high fashion, either as a designer or with a fashion magazine.

This soooo beats her actual fate of winding up in the trailer next door to Frank's.

WHERE ARE YOU FROM?

I was born in Seattle, although my family's originally from Manhattan. We get back there as often as we can.

Is that your super-power? Seeing the future!

But being unable to avoid it. CALL ME CASSANDRA!

Wow! You actually did learn something at Blackwell.

WHY DID YOU COME TO BLACKWELL ACADEMY?

Out here on the Left Coast, there's no better school for someone with my skills and talents to be. I actually find myself enjoying it here despite the lack of any real culture. But I suppose that allows us to concentrate on our studies better, doesn't it?

Don't rub it in...

Was there some kind of hellish exchange program in place? Trade Max to Seattle for Victoria?

Blackwell got the short end of that deal.

Screw you both!

Is that an insult or a proposal? Either way, fuck off. ☺

WHAT IS YOUR FAVORITE THING ABOUT BLACKWELL ACADEMY?

The elite kinds of teachers and students that an institute like this attracts. What else matters?

QUOTE: "I'm working here."

Steph Gingrich

HOMETOWN:
Oakland, California

SPORTS:
Soccer

CLUBS:
Gaming, comics, Geek Grrls Book Club

HOBBIES:
Video games, tabletop games

LIVES:
Off-campus

POST-BLACKWELL PLANS:
My ambition is to attend the DigiPen Institute of Technology in Seattle and study to be a game designer. From there, I hope to work with one of the major studios—maybe Microsoft? Once I have enough experience there, I plan to launch an indie dev studio so I can bring my own vision to the world.

WHERE ARE YOU FROM?
All over the place! My folks finally settled in the Bay Area, so I suppose that's what you might call my home base.

WHY DID YOU COME TO BLACKWELL ACADEMY?
Do you know how hard it is to find a high school that actually encourages you to do artistic things? To embrace the arts at all? Most schools are cutting arts programs, but they're a huge part of the focus here.

There was a D&D group on campus? Dang, I missed ouuuut.

Steph ran a game for me and Mikey. It was actually a lot of fun.

Better than playing pirates?

Nothing's better than playing pirates.

That's why I came here.
Not to see me?! Oh, and that too. ☺

WHAT IS YOUR FAVORITE THING ABOUT BLACKWELL ACADEMY?
How easy it is to get a game rolling here. Everyone seems up to play.

QUOTE: "Life is but a game." *Just wish we could change the difficulty level...*

Never mind D&D, you need a bit of ARRR & ARRR.

Warren Graham

HOMETOWN:
Arcadia Bay, Oregon

SPORTS:
Soccer

CLUBS:
Sci-Fi Movie, Gaming, Gamer Guyz

HOBBIES:
Games, books, hiking

LIVES:
On campus

POST-BLACKWELL PLANS:
I'd like to go to the University of Washington and study physics and math. Ideally, I'd continue on to get my doctorate there and teach. Nothing's better than learning!

WHERE ARE YOU FROM?
My whole family is from Arcadia Bay, although my parents moved up to Seattle after I started school here. With the fishing closed down, they had to look someplace else for work. Fortunately, I can stay here!

Wait. So people can stay behind when their families leave? What about that... MAX?

I came back here to live as soon as I could, Chloe.

WHY DID YOU COME TO BLACKWELL ACADEMY?
Blackwell's reputation in the sciences is fantastic. The kind of things I can learn here should put me well ahead of my fellow students as I go into college.

WHAT IS YOUR FAVORITE THING ABOUT BLACKWELL ACADEMY?
Everything! I mean, it's become my home in so many ways. I'm going to Seattle in the summer, but since I haven't really lived there much, that seems more like a visit than a home.

This is the guy who's sweet on you?

Shhh! Annnd?

Well, he did take a beating from Nathan for me. Not sure what that means beyond the fact he rules for that...

QUOTE: "Cooool."

Basically it means we should all team up and beat the shit out of Nathan.

I'm just going to get a rubber stamp that says FUCK YOU and save myself some time.

Yeah, don't want to strain that cock-knocking hand, Nathan.

FUCK YOU!

Michael North

HOMETOWN:
Arcadia Bay, Oregon

SPORTS:
None

CLUBS:
Sci-Fi Movies, Comics, Gaming, Gamer Guyz

HOBBIES:
Games, reading

LIVES:
On Campus

HOLE TO THE UNIVERSE

POST-BLACKWELL PLANS:
I'm just a freshman, so it's hard to think that far ahead. Maybe I'll follow my brother Drew to wherever he goes. I'm not the athlete he is, so I'll have to work on getting an academic scholarship though. My top choice would be Caltech.

I miss Mikey. He never came back the next year. Wherever Drew ended up, I think Mikey went with him. Probably their dad too.

Think he made it to Caltech? Only if there's any justice in the world.

WHERE ARE YOU FROM?
I'm from Arcadia Bay. You couldn't ask for a better place to grow up.

WHY DID YOU COME TO BLACKWELL ACADEMY?
To get a great education and to watch Drew play sports. So far, so good!

WHAT IS YOUR FAVORITE THING ABOUT BLACKWELL ACADEMY?
There's space for everyone here. Drew, for instance, is a big man on campus, but I fit in just fine too. It's like the school is part of a bigger family for us.

Well, Mikey, when you set a low bar for yourself...

QUOTE: "Let's roll—some dice!"

Then you always win! Wait... That wasn't quite your point, was it? ☺

Nathan Prescott

HOMETOWN:
Arcadia Bay,
Oregon

SPORTS:
None

CLUBS:
Photography,
Vortex

HOBBIES:
Travel,
investing,
art

LIVES:
On campus

Because his family can't stand him at home!

POST-BLACKWELL PLANS:
I plan to go to Stanford, where my family has attended for three generations. That's a huge legacy to live up to. After that, I suppose I'll come back here and help run the family business.

I didn't realize you could make a living at being a dick...
Or at anything else. Useless much?
Ow. I'm pierced! My heart! WHERE IS MY FAINTING COUCH?

WHERE ARE YOU FROM?
My family have been prominent members of Arcadia Bay since the town's founding. There wouldn't be a town here without us.

WHY DID YOU COME TO BLACKWELL ACADEMY?
Was there ever any doubt? This is where Prescotts go! I always knew I'd wind up here, no matter what.

I think I'll bring this up in class as a textbook example of fatalism. You do, and you'll pay!

I'll buy that for a dollar! (Rachel! Loan me a dollar!)

WHAT IS YOUR FAVORITE THING ABOUT BLACKWELL ACADEMY?
The respect the students and staff show everyone, at least when I'm around. They're so supportive. It's like being surrounded by family every moment of your life.

QUOTE: "You can't get away from yourself."

Much as we all try...
BITCH!
I was trying to sympathize with... Oh, forget it!

Chloe Price

HOMETOWN:
Arcadia Bay,
Oregon

SPORTS:
None

CLUBS:
Mathletes

HOBBIES:
Art, music

LIVES:
Off-campus

POST-BLACKWELL PLANS:

I'm on the George Bailey plan: "I'm shaking the dust of this crummy little town off my feet, and I'm gonna see the world. Italy, Greece, the Parthenon, the Colosseum. Then, I'm coming back here to go to college and see what they know."

WHERE ARE YOU FROM?

I was born and raised right here in Arcadia Bay. My parents were born here too. Try as we might, we just can't seem to escape it.

WHY DID YOU COME TO BLACKWELL ACADEMY?

I'll admit, I was reluctant to come here at first. I went to the public schools in Arcadia Bay my whole life, and we townies often think the kids who go to Blackwell Academy are a snooty bunch who look down on those who can't afford to go there. Now that I'm here, though, I see exactly how wrong I was.

How wrong was I? ZERO. ZERO WRONG.

WHAT IS YOUR FAVORITE THING ABOUT BLACKWELL ACADEMY?

Honestly, you can't beat the campus. It's absolutely beautiful here, right up on the edge of town, among the sprawling hills and trees. And the buildings? They're like a blank canvas just waiting for you to make your mark on them! *Literally.*

I thought I recognized your handiwork around here...

QUOTE: "What happens if you do this?"

Justin Williams

HOMETOWN:
Vancouver, Washington

SPORTS:
None

CLUBS:
Sci-Fi Movie

HOBBIES:
Music, skateboarding

LIVES:
On campus

POST-BLACKWELL PLANS:
The day after graduation, I'm going to buy myself a minivan and travel up and down the coast, looking for the best rails to grind on. In September, I'll go to the best college that will let me in. I'm thinking about something in materials engineering.

Gotta admire a guy with ambitions. Not great ambitions, but still. Ambitions.

WHERE ARE YOU FROM?
Vancouver's just on the other side of Oregon's northern border, so it's not so far away. My mom and stepdad live there with the whole rest of the brood, except for my older brother.

WHY DID YOU COME TO BLACKWELL ACADEMY?
My older brother Griffin came here, and we visited him a few times when I was a kid. I fell in love with it straight away. Tucked right between the mountains and the waves… What's not to love?

I have a list! I think I scribbled down here somewhere…

WHAT IS YOUR FAVORITE THING ABOUT BLACKWELL ACADEMY?
People here are generally pretty chill. They mostly accept you for who you are. And if they don't you can just ignore them.

See? I wish I could get away with that.
He paints such a pretty picture…

QUOTE: "You're all right."

Academic Departments

At Blackwell Academy, our faculty is divided up into several different departments, each of which tends to a particular aspect of our students' education.

This is less to share the credit and more to split the blame...

English

We concentrate on the classics, with a particular emphasis on early and mid-20th-century writers like Joseph Conrad, Ernest Hemingway, F. Scott Fitzgerald, Dorothy Parker, and J. D. Salinger. This gives our students a solid grounding in Western culture to prepare them for their college years.

Nothing like reading long-dead authors to get you ready for a future they could never have imagined.

DEPARTMENT HEAD: Bernadette Hoida

Fine Arts

Do we make art to live or live to make art? This the central question we explore in the fine arts department at Blackwell Academy. We are medium-agnostic, allowing students to explore their talents and develop their skills with any artform that appeals to them.

Personally, I'm extra-large agnostic.

DEPARTMENT HEAD: Charles Cole

You don't believe in God. If there is a God, I can only believe she's truly pissed at me.

Life Skills

At Blackwell Academy, we prepare our students not just to enter the best colleges, but to live their best lives. We teach them about everything from cooking and cleaning, to how to save money and invest. While we care for our students while they are with us, once they depart, they are prepared to live independently and well.

DEPARTMENT HEAD: Eleanor Terry

I suppose it's no surprise I epically failed this...

Not to anyone who's ever met you!

Mathematics

Mathematics is the secret language of the universe, the means by which we describe how things function both on their own and in relation to the world around them. We teach our students to not only read this ancient tongue but to speak it with the fluid confidence of a poet.

You can tell they didn't let the people in the math department write the descriptions here.

DEPARTMENT HEAD: Sam Stein

It would have said something like $a^2 + b^2 = c^2$, where a = Arcadia Bay, b = Blackwell, and c = college.

Christ! You're so fucking... earnest! :)

Performing Arts

It's important not to just fill a student's head with knowledge, but also to help them understand how to create and express ideas of their own. We instruct students in music, drama, and forensics so that they may one day inspire others in the same way that they've been inspired.

Hear that Nathan?
YOU DON'T HAVE TO BE YOUR DAD! Oh, wait... Yeah, you do.

DEPARTMENT HEAD: Travis Keaton

FUCK OFF!

Physical Education

What's in a student's head means nothing. ~~if~~ !They don't understand what's going on with their bodies. ~~We do our best at Blackwell Academy to encourage our students to develop fitness habits that will help keep them healthy and well throughout their entire lives.~~

There.
Fixed it!

DEPARTMENT HEAD: Juan Edwards *It's true what they say.*
Blackwell is obsessed with balls.

Science and Technology

In Blackwell Academy's science department, we seek to explain how the universe works, both at the astronomical and microscopic levels, and how that deeper knowledge allows us to understand things at the human level as well. In that way, we prepare our students to realize how our actions impact the world around us too.

If I said you had a heavenly body, would you take me to a sexual harassment tribunal?
50/50 chance.
I like those odds!

DEPARTMENT HEAD: Michelle Grant *I like Ms. Grant, but this seems to maybe be overselling this.*

Social Sciences

Science isn't just about how the universe works but how we work with each other within it. We provide a broad range of courses, from Geography to Political Science to Economics to Psychology. In each case, we show how we can apply the scientific method to understanding our society and ourselves both better and deeper.

How are Geography and Psychology in the same department? In what world does that make sense?

DEPARTMENT HEAD: Percival Jackson

World Languages

What good is it to know everything in the world if you can't communicate it to the entire world? At Blackwell Academy, we give students a strong grounding in all sorts of world languages, from Latin and Greek all the way up to Spanish, French, and now even Mandarin and Cantonese.

A.K.A. "Put the kids in front of a computer and teach them something they could learn at home..."

DEPARTMENT HEAD: Nora Eaton

BUTT OUT!!

Everyone except MAX + CHLOE

Here beginneth Max (+ Chloe's) exclusive, secret + artistically majestic Gallery!

Chloe's Room
Joyce would call it a pig sty. To me it just feels right.

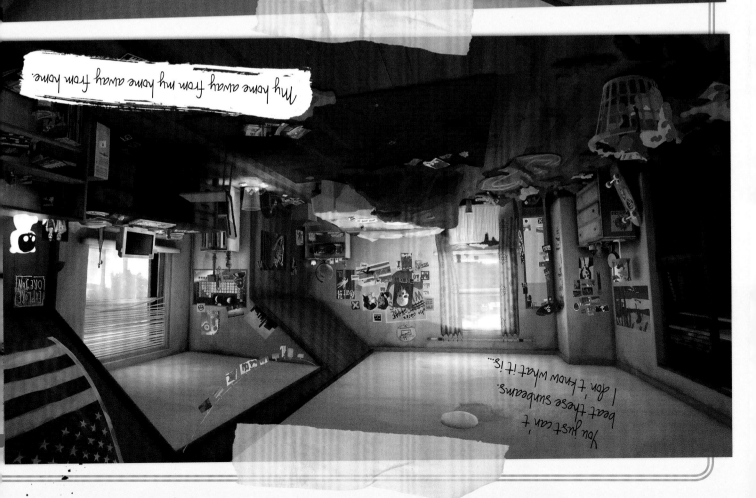

My home away from my home away from home.

You just can't beat these sunbeams.
I don't know what it is...

When I first lived in Arcadia Bay, I think I spent more time at Chloe's house than mine!

One day I'll get my hands on the sweet, sweet engine inside this chassis and... swap it into my beloved, crappy ol' truck.

TOP SUPPORT
MECHANISM IN BACK
to GRAPPLE LOWER

Lever

Chloe's step-dad means well — for a total jackass.

David seems to have taken over Chloe's garage. Just makes me miss William that much more.

Just doesn't seem the same with David there in William's place.

I remember the time capsule.

It's a romantic if
smelly way to travel...

I like how railroad
tracks vanish at the
perspective point as
you walk along them.

I'm so glad
you're my partner
in crime.

My Room! Just the way I like it for now.

STILL 8-BIT

For such a fractured wall, looking at it makes me feel whole.

A painting I did before the storm!

It's not just because of this photo that
I'm seeing this lighthouse EVERYWHERE.
Freud would have a field day, you need to
get laid.

Nice. But is there any chance the school will discipline Nathan for it?

I love living in the dorm, even if the Prescotts have their name on the place.

I can't believe she fixed it up. That girl can do anything!

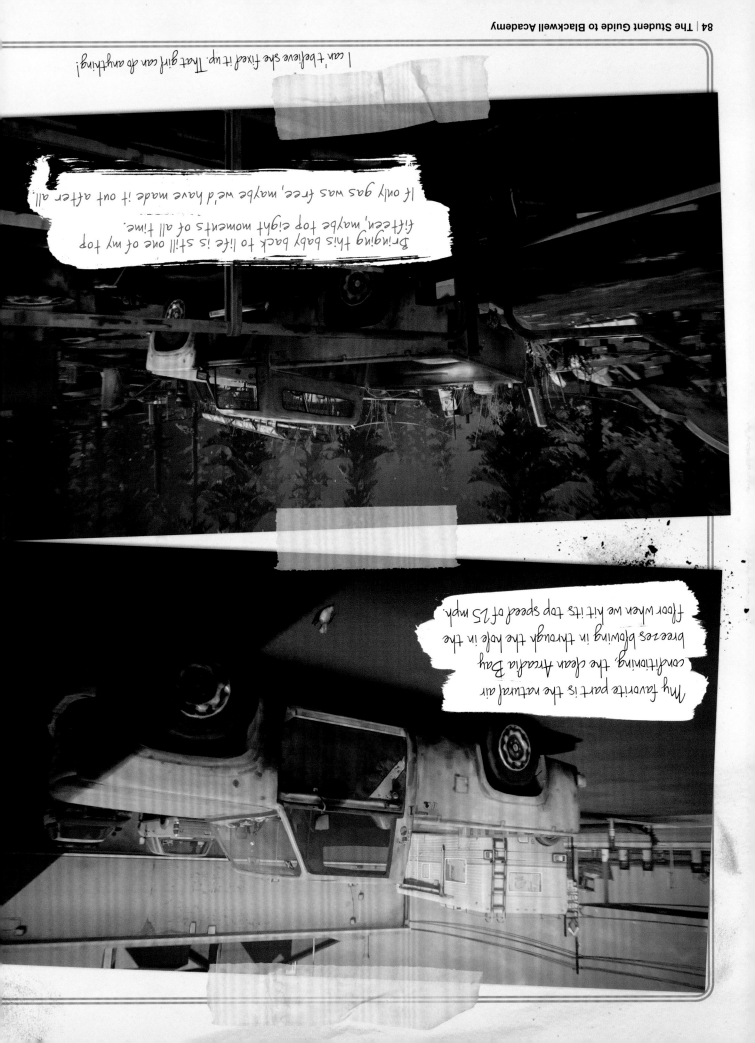

Bringing this baby back to life is still one of my top fifteen, maybe top eight moments of all time.

If only gas was free, maybe we'd have made it out after all.

My favorite part is the natural air conditioning, the clean Arcadia Bay breezes blowing in through the hole in the floor when we hit its top speed of 25 mph.

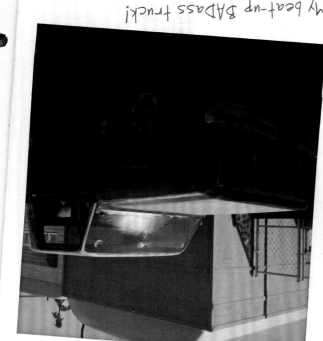

My beat-up BADass truck!

AKA The Chloemobile!

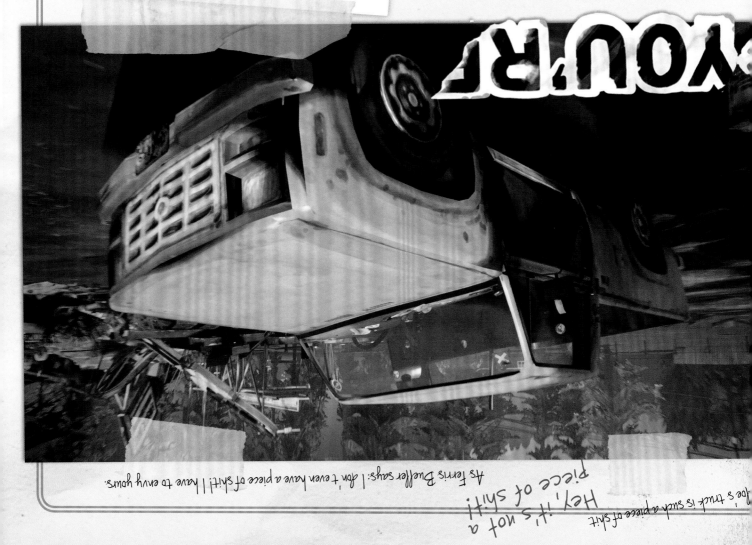

YOU'RE

Joe's truck is such a piece of shit.

Hey, it's not a
piece of shit!

As Ferris Bueller says: I don't even have a piece of shit! I have to envy yours.

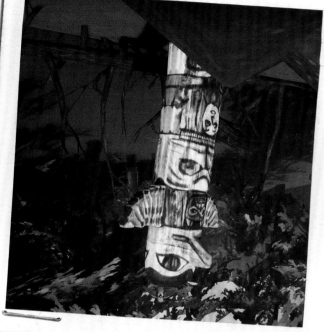

Ever wonder if there's magic
watching over Blackwell?
Does CCTV count?

The place to be at Blackwell when you got no place to be.

HEYYYY Even your brooding is adorable.

wistful whimsy would be the DEATH of ME.

It's a good job I love you or all this

kind of acoustic guitar'd music video.

I don't know how you do it, Max. You make even a goddamn walk in the park look like some

That doe was amazing! Jane Dee!

One thing you forget about Arcadia Bay is the beauty of the land around it

What a nightmare Chloe might hate Arcadia Bay, but would even she want to see it destroyed?

Tornadoes, like
the Vortex Club
which is named
after them, suck.

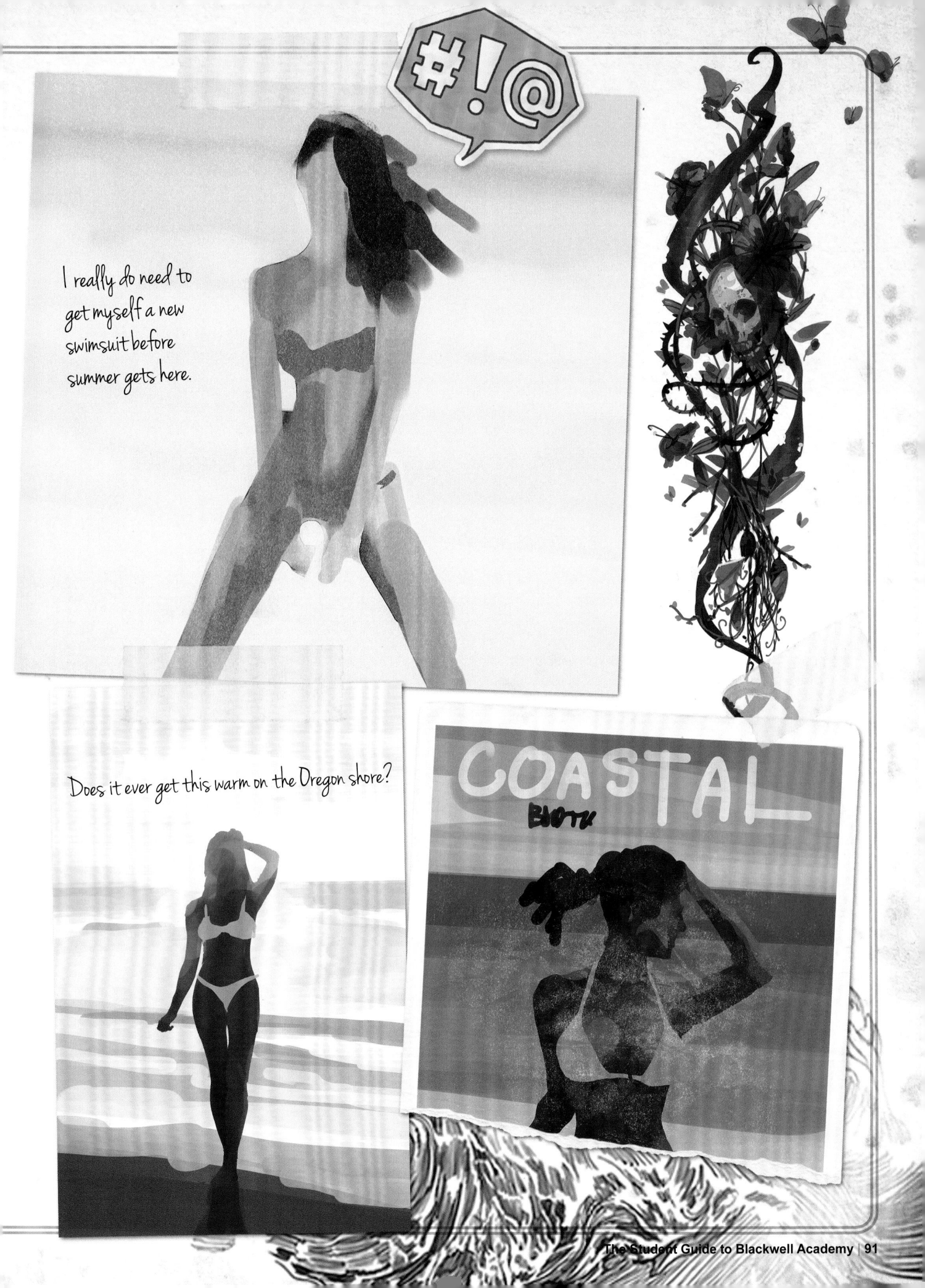

I really do need to get myself a new swimsuit before summer gets here.

Does it ever get this warm on the Oregon shore?

COASTAL

I had a vision of a doe like this one.
What did it mean?

Frank's delightful dog!
POMPIDOUUUUUU!

GHERKIN.

Samuel's spirit animal.
Wait, we're not supposed to say that any more...
Samuel's nut avatar. Wait.

"Art harder, motherfuckers!" — Chuck Wendig

Chloe should get off her butt and get into something like this. Those Sharpies aren't going to blunt themselves...

I'd get off my butt if you weren't RAMMED SO FAR UP IN IT

No one will miss this, right?

It takes a friend like Chloe to help you see
how one person's junk is another person's art.

Don't think of it as trash. Think of it as garbage that
hasn't been set alight yet.
 Was that another DIG?
This time, genuinely not. SOMEONE'S pretty sparky.
 CHLOE PRICE

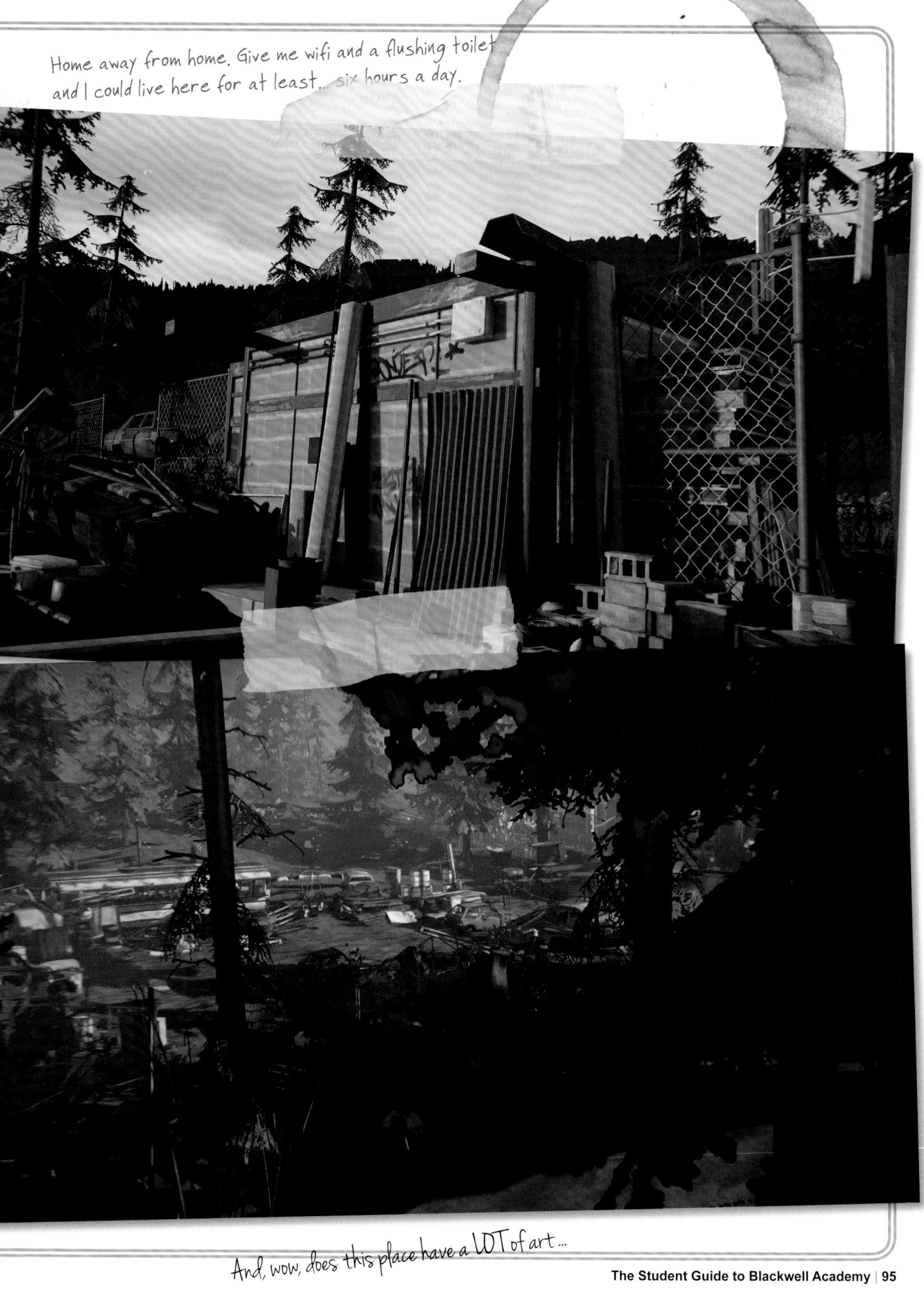

Home away from home. Give me wifi and a flushing toilet
and I could live here for at least... six hours a day.

And, wow, does this place have a LOT of art...

Chloe's favorite supplier. Scummy but all right?
Just... pay him on the regular. Or if you don't pay him,
avoid him on the regular. But yeah. Good dude. Just...
don't play knife-y knife-y with him or anything.
Jesus, Chloe. HOW do you know this guy?

I guess drug dealers can't afford great places. And hey, at least Frank delivers!

Me and Max, BANGING in the AFTERNOON.

? ? ?

AFTERNOON DELIGHT, SHOOTIN' THINGS, ALRIGHT!
This is why sane people want gun control, Chloe.

BANG BANG MY BABY SHOT ME DOOOWWWNNN

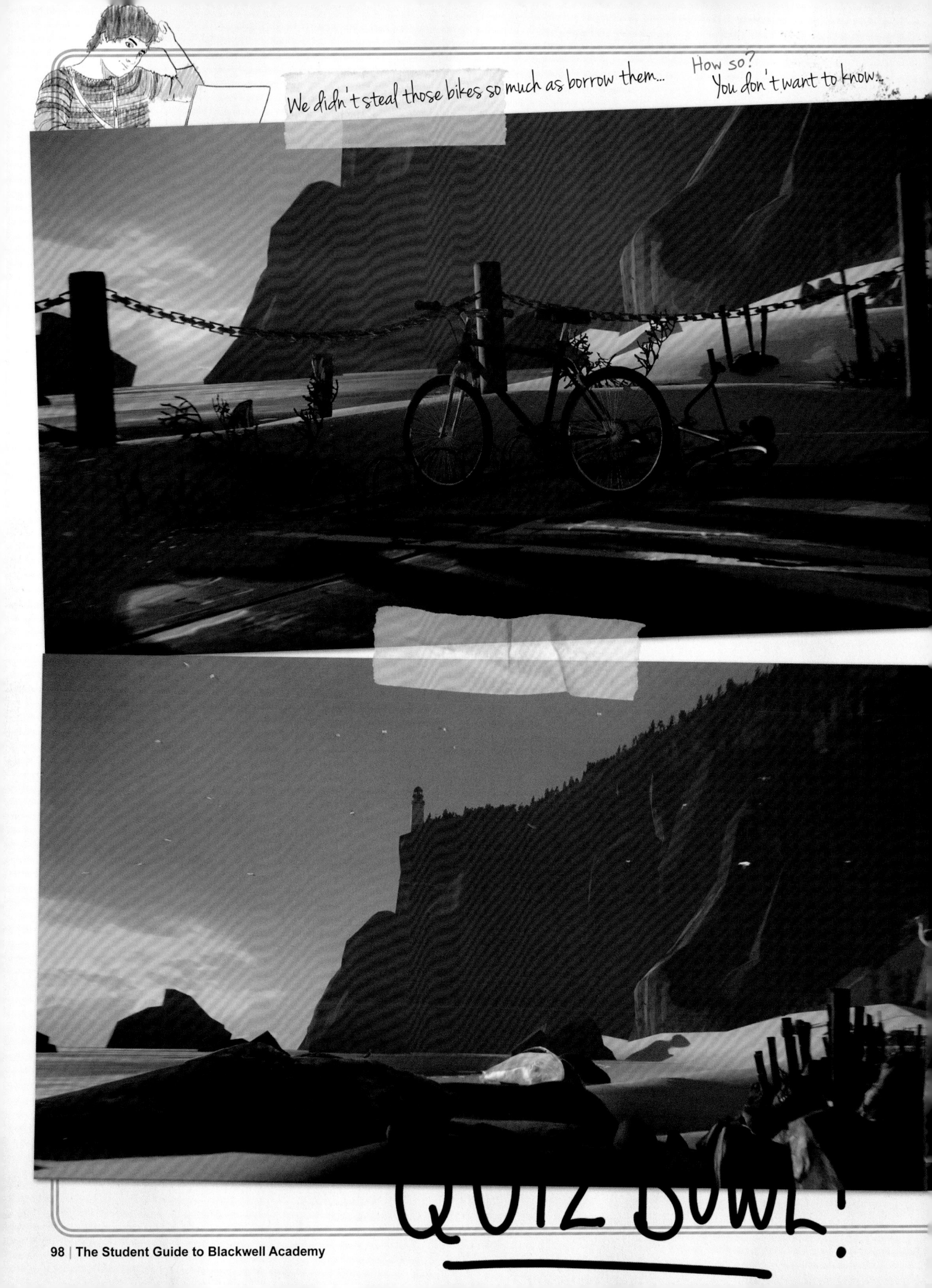

We didn't steal those bikes so much as borrow them... How so? You don't want to know...

QUIZ BOWL!

How do you weigh a whale?

Chloe, I'm not sure that's appropriate With a crane and a really large stretcher-type situation,

and a lot of patience. This is a very sad occasion, Max, I don't appreciate you lowering the tone with your jokes.

I like these photos - they're so peaceful.

KEYMASTER CHLOE

HELP!!
LOST WALLET!

PLEASE CALL:

Well, we found the note at least!

Nothing more American than
a truck ready to hit the road.

Where was this, I wonder?

Dude or douche? The jury's still out, I'm afraid.

That's Samuel, the Squirrel Master!

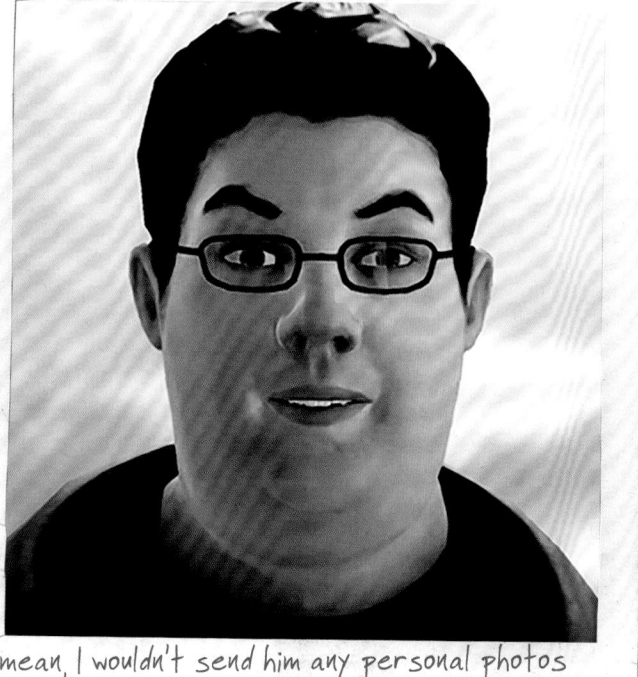

I mean, I wouldn't send him any personal photos online or anything, the guy looks like he has three terabyte harddrives of spank-bank folder, but he can sketch, I'll give him that.

CHLOE!

Two minutes later, her drone hit me in the head. I'm pretty sure nobody is THAT bad at spatial navigation. Oh, it's because she hates you because Warren likes you. Is THAT it?

My nemesis, my foe, my ex-Principal. We meet again, in Polaroid form. I would draw a massive weiner on this, but a) I'm too classy a dame, and b) kinda homophobic, so no. But imagine one there if you're more vindictive than THIS gal.

Shiner on, you crazy diamond. And, uh, don't let that toxic masculinity brewing inside you go unexamined, okay?

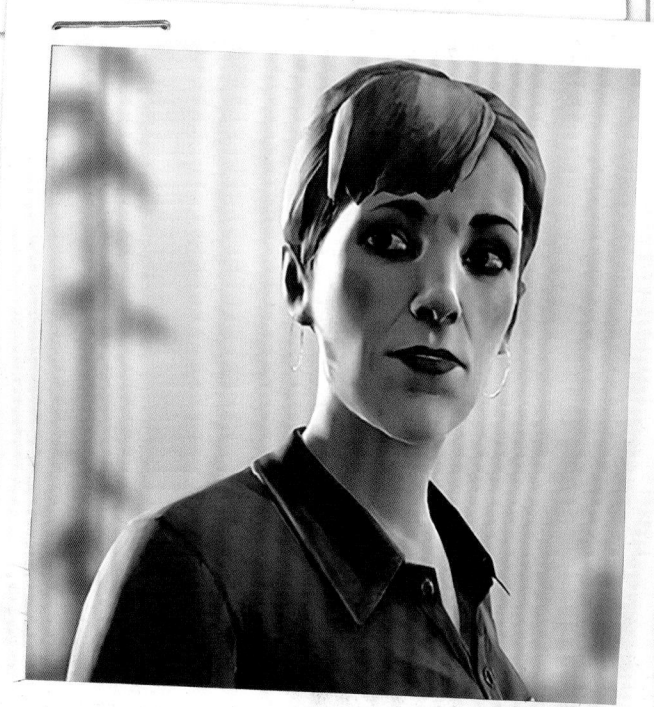

I can't believe she actually posed for this. I mean, her lips are pursed to tell you to FUCK OFF the minute the shutter clicked, but sure. Victoria just looks like that ALL the time.

True, I just never thought I'd see you write that down.

The Mom, outside her natural habitat of the Home and the Work, basking in a brief moment of natural light before being forced inside once more. Pity her. Pity herrrrrrr

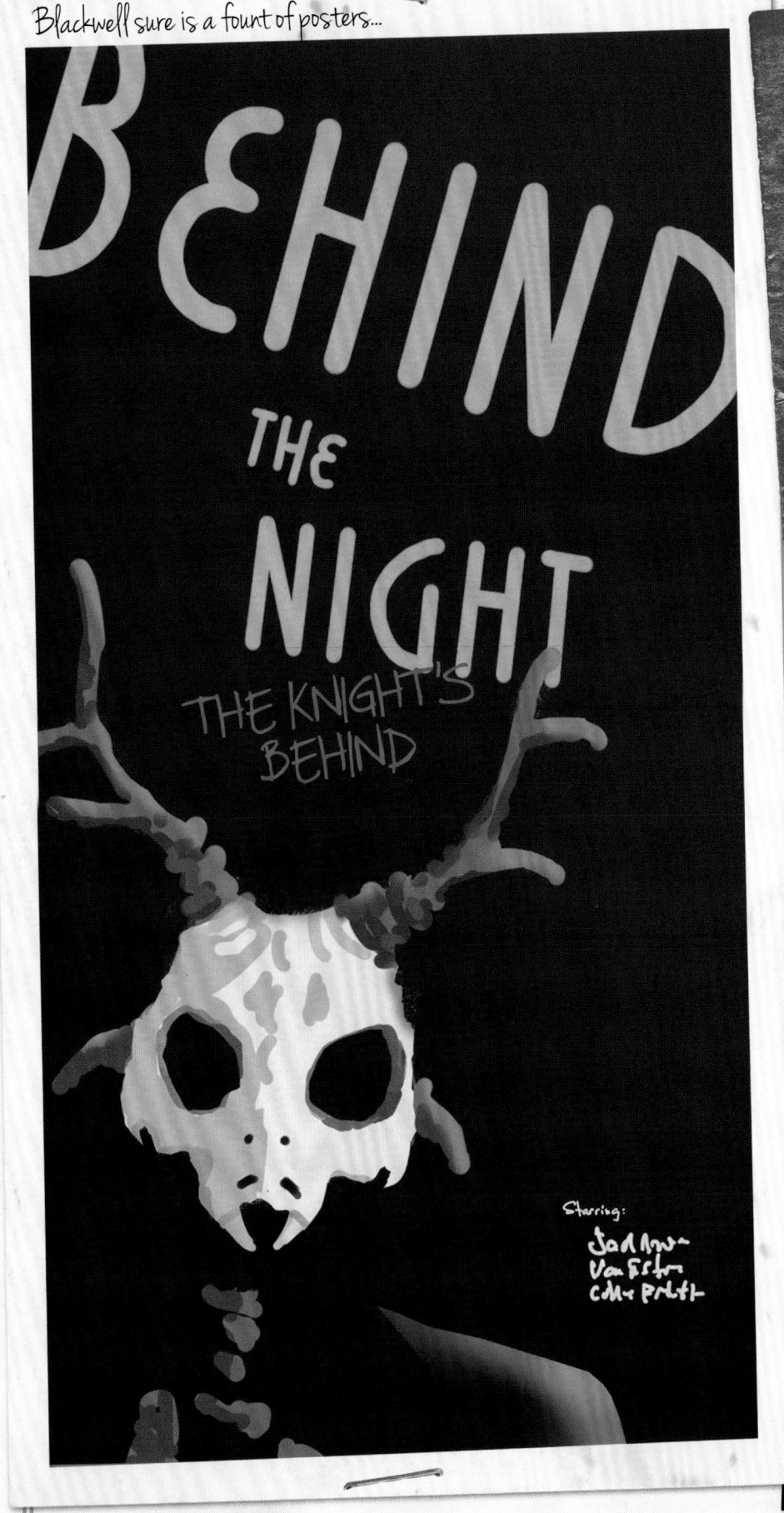

Blackwell sure is a fount of posters...

BEHIND THE NIGHT

THE KNIGHT'S BEHIND

Starring:

Shakespeare IS MY HOMEBOY

Man, I miss William.

Butterflies have such an effect...

look, I adore the play of light through the windows in this room, but even I shiver a bit at classrooms empty of people.

I don't miss this place AT ALL.

just somethin' menacing about classrooms in general, Max. No other people in them just means that the general spread of bad happenings is all going to bad happen to YOU.

At least you don't have the ride the bus back home after school.

You really captured the hopelessness of the place here...

Any idea what they were going for here? Abstract art is so... abstract.

7-70

This is shot through the bottom of a drinking tumbler, if you can believe it.

I can believe it's not REGULAR Tumblr, there's no slash in it.

I don't get it

Big boys beating the crap out of each other. What's not to love?

The Devil Bunnies rock!

I'm having such a good time I'm wearing it all

Some BODY
once told me
This closet
cannot hold me
I'm a skellington:
gimme your head

Well he was
FEMUR kinda
dumb with
His left-leg and
his BUM
Bent in the
shape of an L on
his SKULL HEAD

Dammit,
Chloe, now
that's stuck
in my head

Dancing with Death? He can move those bones!

Can't believe you kept these photos of Rachel's home.

I miss her so much!

We'll find her!

It was a beautiful place.
Even if her dad made
it a hell for her...

These are like crime scene investigation 'BEFORE' pictures.
The insurance covered ALL the breakages. Didn't even come out of my allowance.

The true criminal, as ever, gets away with her crimes.

Miss you

A more perfect shade of cyan I have never seen.

I KNOW, right?

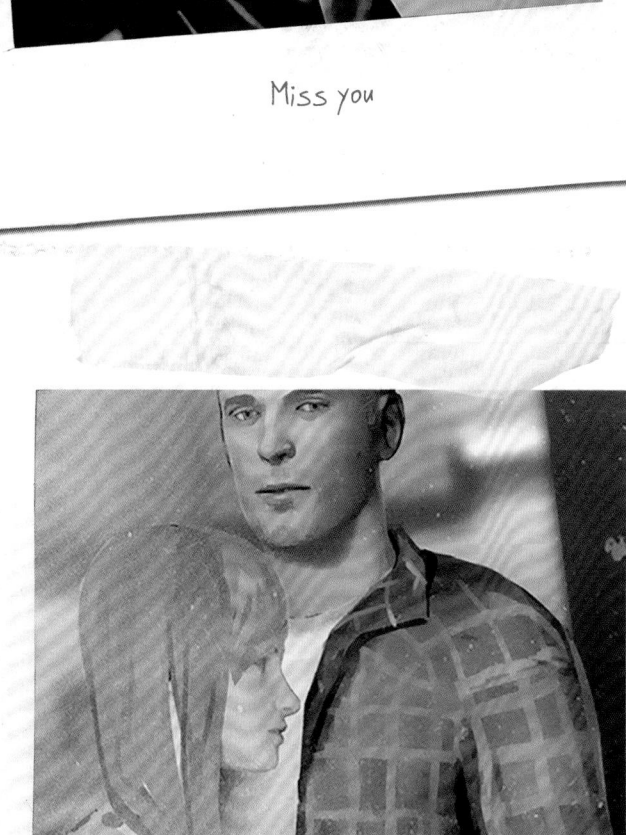

Fuck, was I ever that young?

Well, at least THIS one came back to me.

Took me a while, and I'm still sorry.

Are these pineapples filled with lemons?
Life must have given the artist lemons...

Are these pineapples filled with lemons?
Life must have given the artist lemons...

I mean, as shitholes owned by psychopaths go, it was all right...

Max!!! Throw in a 'hella' and my work transforming your skittish self is DONE

Maybe YOU packed meat

Maybe it packed meat??

THE CHAINS bounce off ALL

As in, the sound waves

CHAIN OFF THE shitholes are in these acoustics but the a lumber yard, remains of crumbling about the what it is I don't know

The Old Mill!!! My kinda dive!

It might not be as nice as home, but the company's much better!

Is breezeblock my canvas, scrawling my metier?
Short answer, yes. Long answer: get bigger canvases.

Our sanctuary!